STAR WARS™

ORIGAMI 2

STAR WARS™

ORIGAMI 2

34 MORE PROJECTS FROM A ——— GALAXY FAR, FAR AWAY . . .

CHRIS ALEXANDER

WORKMAN PUBLISHING ✸ NEW YORK

Library of Congress Control Number: 2020938522
ISBN 978-1-5235-0873-0

Design by Terri Wowk

Origami paper illustrations by Rui Ricardo
Origami designs, diagrams, and text by Chris Alexander
Image on page 28 by Wizards of the Coast

Workman books are available at special discounts when purchased in bulk for
premiums and sales promotions as well as for fund-raising or educational use.
Special editions or book excerpts can also be created to specification.
For details, contact the Special Sales Director at the address below or
send an email to specialmarkets@workman.com.

Workman Publishing Co., Inc.
225 Varick Street
New York, NY 10014-4381
workman.com

WORKMAN is a registered trademark of Workman Publishing Co., Inc.

Printed in China
First printing August 2020

10 9 8 7 6 5 4 3 2 1

ACKNOWLEDGMENTS

Many people helped this book come to life, and I'd like to use this space to thank some of them.

First, there is Empress Nicole Black. Whenever I'd create a new model, she'd be my test audience. Her honest appraisals of the models made this a much better book.

My friends Richard and Sarah Woloski and their podcast *Skywalking Through Neverland*.

Traci Todd, Pam Bobowicz, and Gracie Elliott for making this sequel possible.

Terri Wowk and Sara Corbett for making this book as eye-popping and polished as it is.

Rui Ricardo for turning my finger paintings into beautiful origami tear-out sheets.

Beth Levy for making sure everyone was on the same page.

All the *Star Wars* fans who attended my origami workshops and test-folded many of these models.

And of course, George Lucas, the man who created the galaxy far, far away.

CONTENTS

PART ONE
THE BASICS

Origami Definitions, Symbols,
and Basic Folds 1

Important Origami Bases................. 12

PART TWO
THE PROJECTS

Lightsabers 19

Porg .. 25

T-16 Skyhopper............................... 29

Super Star Destroyer, the *Executor*.................35

BB-8 ... 41

Darth Vader 47

Death trooper helmet....................... 53

Obi-Wan Kenobi's Jedi starfighter 59

Sebulba's podracer.. 65

Supreme Leader Snoke................................. 73

First Order Star Destroyer, the *Finalizer*........... 81

First Order Stormtroopers.............................. 89

Sith trooper helmet 95

K-2SO .. 97

Kylo Ren's TIE whisper................................. 105

Y-wing... 113

Lando Calrissian's *Millennium Falcon* 121

General Grievous' starfighter,
the *Soulless One* 129

Lando Calrissian.. 135

Sith Infiltrator ... 145

Kylo Ren's TIE silencer 151

A-wing .. 157

D-O .. 165

Finn ... 173

Kylo Ren's mask .. 181

Rey's Jakku speeder 187

Poe Dameron's T-70 X-wing 195

Praetorian Guard .. 205

U-wing .. 217

Zorii Bliss' helmet .. 223

TIE striker .. 227

INDEX

Projects by Level of Difficulty 232

PART ONE
THE BASICS

ORIGAMI DEFINITIONS, SYMBOLS, AND BASIC FOLDS

Origami figures are made with just two folds, the valley fold and the mountain fold. All of the following folds are just combinations of these. As you study the diagrams, pay attention to the type of line used to represent each crease. This will indicate whether it should be a mountain or valley fold.

THERE ARE TWO GOLDEN RULES OF ORIGAMI.

GOLDEN RULE 1: ACCURACY!

As you start to line up your paper to make a crease, be as *accurate* as possible. Try to get edges aligned as best you can, points directly on top of other points, lines matching lines, and so on. The more accurate you are, the easier later steps will be and the better your model will look when finished.

GOLDEN RULE 2: CREASING!

Once you have your paper accurately aligned for folding (see Golden Rule 1) *crease* the paper as sharply as you can. Run your fingernail along the crease spine until it's very crisp. The sharper your creases are, the easier later steps will be and the better your model will look when finished.

The diagrams in this book are designed to help you visualize the steps. Because of this, some of the edges are offset. Do not take them literally. For example, in the center diagram at right the edges do not meet in the middle. But when properly folded, there will be a sharp point at the top, and the edges will line up perfectly.

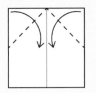 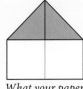

A typical diagram *What your paper should look like*

When working on a fold, glance ahead to the next step to see what it should look like when completed. Remember Golden Rules 1 and 2.

This book contains instructions for re-creating 34 objects, creatures, and characters from the *Star Wars* universe with just a simple piece of paper (or two). Though you can do the projects in any order you choose, there are four levels of difficulty: Youngling, Padawan, Jedi Knight, and Jedi Master. (See page 232 for a list of the projects organized by level.) Unless you're already an origami guru, you might want to start with the Youngling or Padawan models first.

SIDE ONE

Side one of the origami paper is represented by the white side of the diagram.

SIDE TWO

Side two of the origami paper is represented by the colored side of the diagram.

ORIGAMI DEFINITIONS, SYMBOLS, AND BASIC FOLDS (CONT.)

VALLEY FOLD

The valley fold, represented by a dashed line, is the most common fold. The paper is creased along the line as one side is folded toward you. A "valley" is formed in the process.

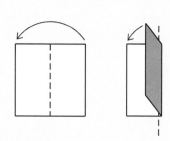

MOUNTAIN FOLD

The mountain fold is represented by a dashed and dotted line. The paper is creased along the line as one side is folded away from you. A "mountain" is formed as the paper is folded.

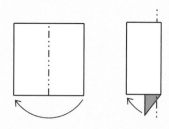

MARK FOLD

The mark fold is used to make a crease that will be used as a reference in a later step. Lightly fold on the line as indicated and then unfold. Ideally, the crease will not be visible when the model is finished.

EXISTING CREASE

A thin line represents a crease formed in a previous step and is used for orientation or as a reference in the current step.

X-RAY LINES

The dotted line serves two purposes. In most cases, it represents a fold or an edge underneath another layer of paper. It is also used to represent an imaginary extension of an existing line.

TURN OVER

This symbol means turn the model over to the other side.

ROTATE

This symbol means rotate the figure to a new position.

CUT

This symbol means you should cut the paper along the indicated solid line.

REVERSE FOLD

To make a reverse fold (sometimes called an inside reverse fold), put your finger inside the pocket to spread it open. Then, push down on the spine of the section to be reversed until the section is folded inside itself along existing creases.

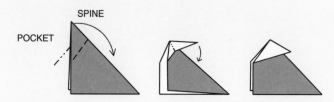

OUTSIDE REVERSE FOLD

To make an outside reverse fold, open the pocket a bit and flip the point backward over the spine along existing creases. It's a little like peeling a banana.

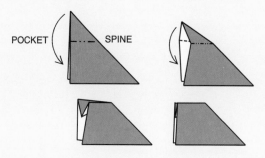

PIVOT FOLD

The pivot fold adjusts an existing point. The base of the figure is pinched while the point is swiveled into its new location and is re-creased. In this example, pinch point A, while pivoting point B upward.

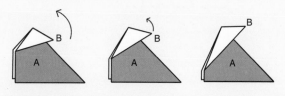

Start with an outside reverse fold.

HOW TO MAKE A SQUARE

The only thing you will need to create an origami model is a square piece of paper. Specially designed origami paper is provided at the end of this book, and you can purchase origami paper in craft stores, online, and in some bookstores. But if you want to practice your techniques, this is a simple way to create your own origami paper! A square can be made out of any rectangle by following these steps.

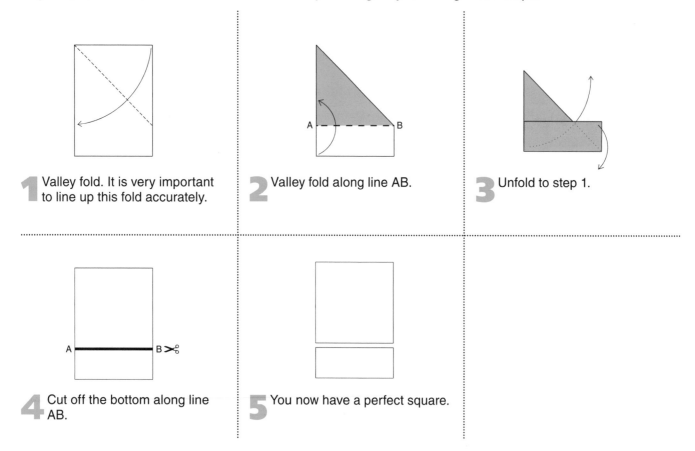

1 Valley fold. It is very important to line up this fold accurately.

2 Valley fold along line AB.

3 Unfold to step 1.

4 Cut off the bottom along line AB.

5 You now have a perfect square.

HOW TO MAKE AN EQUILATERAL TRIANGLE

An equilateral triangle has 60-degree angles at each of its corners and has sides that are exactly the same length. Lucky for us, origami is based on geometric concepts. You won't need a protractor or ruler to map out the shape. This special triangle can be made from any rectangular or square piece of paper. Simply follow these steps.

1 Mark fold.

2 Valley fold so corner A lies on crease BC.

3 Valley fold along edge AB.

4 Unfold completely.

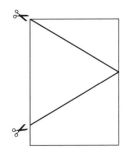

5 Cut along the indicated lines.

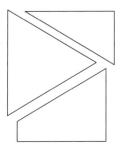

6 You now have an equilateral triangle.

PLEAT FOLD

This fold resembles the pleat on a skirt when finished. You can think of it as two reverse folds.
This arrow indicates a pleat fold:

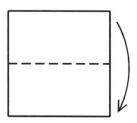

1 Valley fold in half.

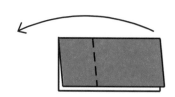

2 Valley fold.

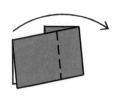

3 Valley fold.

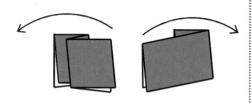

4 Unfold to step 2.

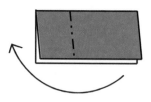

5 Start of pleat fold. Inside reverse fold along crease made in step 2.

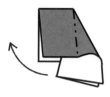

6 Halfway through, reverse fold.

7 Inside reverse fold along crease made in step 3.

8 Halfway through, reverse fold.

9 Finished pleat fold.

RABBIT EAR FOLD

This fold is used to narrow a point. In this example, the bottom half of the two existing creases are used, and two new creases are formed: the valley fold from the point to the center and the mountain fold from the center to the edge.

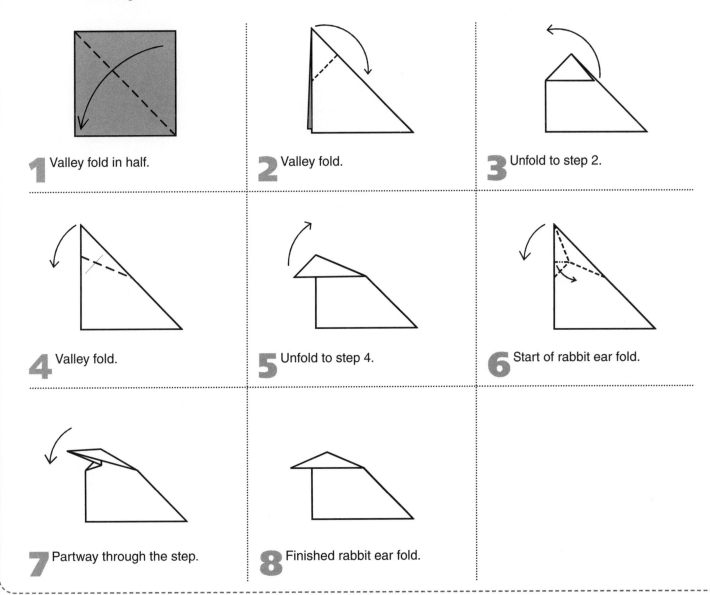

1 Valley fold in half.

2 Valley fold.

3 Unfold to step 2.

4 Valley fold.

5 Unfold to step 4.

6 Start of rabbit ear fold.

7 Partway through the step.

8 Finished rabbit ear fold.

SQUASH FOLD

A squash fold is formed by lifting one edge of a pocket and reforming it so the edge becomes a crease and an existing crease becomes a new edge.

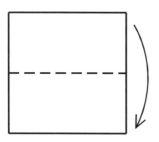

1 Valley fold in half.

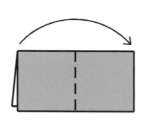

2 Valley fold in half.

3 Valley fold the top layer.

4 Unfold to step 3.

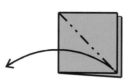

5 Start of squash fold.

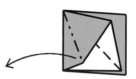

6 Spread open the paper.

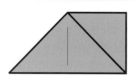

7 Finished squash fold.

PETAL FOLD

Petal folds are used to isolate a point. This example starts with a waterbomb base (see p. 13). As the point is lifted, two new valley folds are added at the bottom.

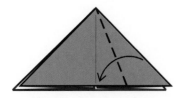

1 Start with a waterbomb base. Valley fold right edge to centerline.

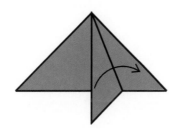

2 Unfold to step 1.

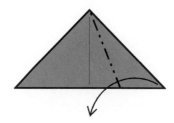

3 Squash fold.

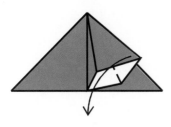

4 Halfway through the squash.

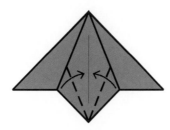

5 Valley fold outside edges to centerline.

6 Unfold to step 5.

7 Start of petal fold.

8 Fold the point to the top.

9 Finished petal fold.

SINK FOLD EXAMPLE 1

A sink fold requires unfolding a portion of the model. The section to be sunk is pushed inside out along existing creases, and the model is then re-formed. No new creases are added. This arrow indicates a sink fold: ∨

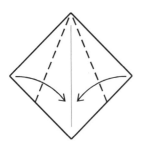

1 Valley fold outside edge to centerline.

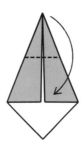

2 Valley fold.

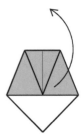

3 Unfold to step 2.

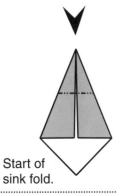

4 Start of sink fold.

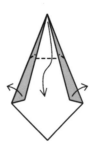

5 Spread open the sides.

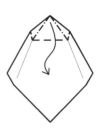

6 Fold the point down.

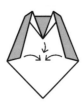

7 Collapse the sides.

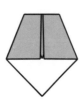

8 Finished sink fold.

SINK FOLD EXAMPLE 2

This example of a sink fold starts with a waterbomb base (see p. 13).

1 Start with a waterbomb base. Valley fold.

2 Unfold to step 1.

3 Start of sink fold.

4 Spread the model apart.

5 Push the top in.

6 Finished sink fold.

IMPORTANT ORIGAMI BASES

THE PRELIMINARY BASE

Bases are the building blocks of origami. The preliminary base is used as a starting point for many origami models.

1 Valley fold.

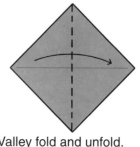

2 Unfold.

3 Valley fold and unfold.

4 Turn the paper over.

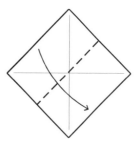

5 Valley fold and unfold.

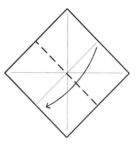

6 Valley fold.

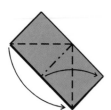

7A Squash fold.

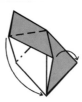

7B Halfway through the step.

8 Finished preliminary base.

THE WATERBOMB BASE

The waterbomb base is another common starting point for many origami models.

1 Valley fold.

2 Unfold.

3 Valley fold and unfold.

4 Turn the paper over.

5 Valley fold and unfold.

6 Valley fold.

7A Squash fold.

7B Halfway through the step.

8 Finished waterbomb base.

DISPLAY STAND

This little stand can be used to show off your origami models. Start with a piece of paper about a fourth of the size that you used for the model. Steps 9 through 13 can be adjusted to position the model to your liking.

1 Valley fold and unfold.

2 Valley fold.

3 Valley fold and unfold.

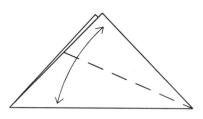

4 Valley fold and unfold.

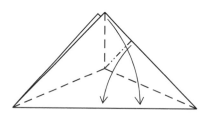

5 Rabbit ear fold.

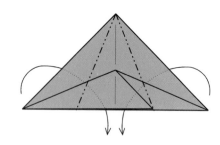

6 Mountain fold.

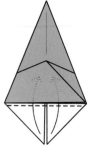

7 Valley fold into the top pockets.

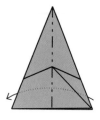

8 Mountain fold.

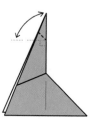

9 Valley fold and unfold. There are no guide folds for this step.

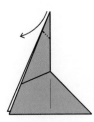

10 Reverse fold.

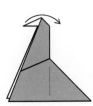

11 Reverse fold as far as it will go.

12 Spread the top open to hold your model.

13 Finished display stand.

PART TWO
THE PROJECTS

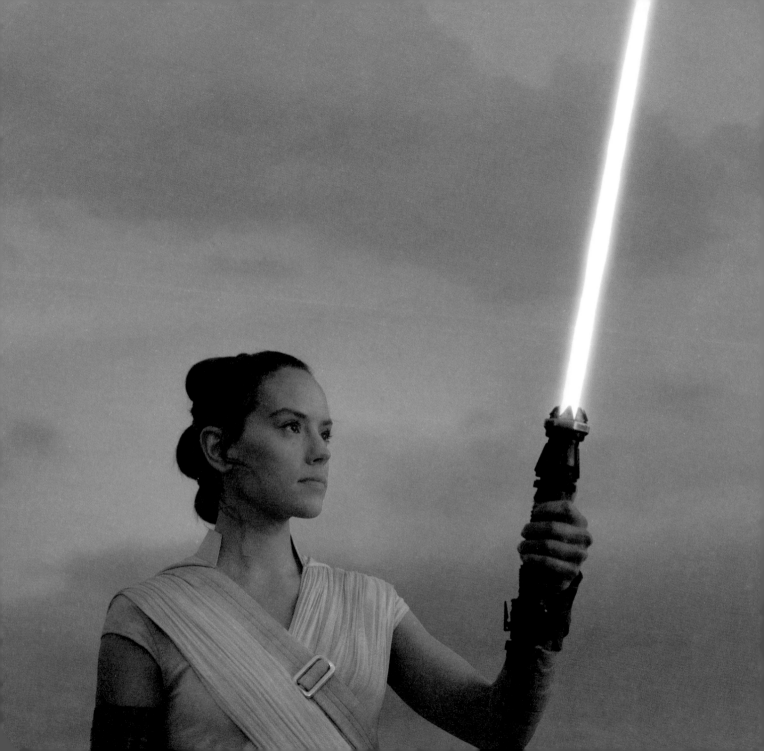

LIGHTSABERS

The lightsaber was an elegant weapon dating back thousands of years. It had a power source that generated a massive amount of energy that was then focused through a kyber crystal, which stabilized the energy into a solid blade of light.

After Rey defeated Emperor Palpatine at the Battle of Exegol, she constructed her own lightsaber from pieces of her quarterstaff, her weapon of choice when she was a scavenger on Jakku. Rather than the standard button-and-switch trigger, she designed a rotating activation matrix to trigger the blade release. The blade was an unconventional gold.

The kyber crystal that powered Kylo Ren's lightsaber was cracked, and produced a jagged blade in a menacing shade of red, along with dangerous amounts of excess energy. It had a crossguard hilt, with a vent on each side where excess energy was diverted and created two smaller lateral blades.

HOW TO FOLD: REY'S LIGHTSABER

1 Valley fold and unfold.

2 Valley fold and unfold.

3 Cut along the crease formed in step 2, or start with a 1:4 rectangle, colored side down.

4 Start blade colored side down. Valley fold and unfold.

5 Valley fold and unfold.

6 Mark fold.

7 Valley fold to the crease formed in step 6.

8 Mark fold.

9 Turn over.

10 Valley fold corner A to the crease formed in step 5. Repeat on the bottom corner.

11 Valley fold. The crease goes through the intersection formed in steps 5 and 7.

12 Mountain fold the corners A into the pockets B. This will turn the model into a triangular tube.

13 Finished Rey's Lightsaber.

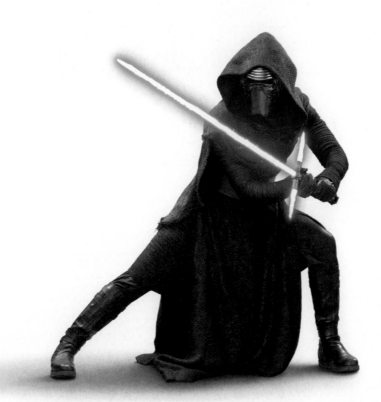

HOW TO FOLD: KYLO REN'S LIGHTSABER

1 Valley fold and unfold.

2 Valley fold and unfold.

3 Cut along the crease formed in step 2, or start with a 1:4 rectangle, colored side down.

4 Start blade colored side down. Valley fold and unfold.

5 Valley fold and unfold.

6 Mark fold.

7 Valley fold to the crease formed in step 6.

8 Mark fold.

9 Mountain fold and unfold.

10 Valley fold and unfold.

11 Valley fold.

12 Valley fold and unfold.

13 Reverse fold on the creases formed in step 12.

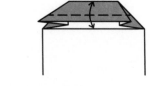

14 Valley fold the colored area in half and unfold.

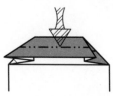

15 Sink fold on the crease formed in step 14.

16 Mountain fold on the crease formed in step 9.

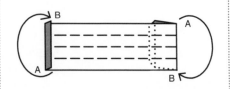

17 Valley fold the corners A into the pockets B. This will turn the model into a triangular tube.

18 Finished Kylo Ren's Lightsaber.

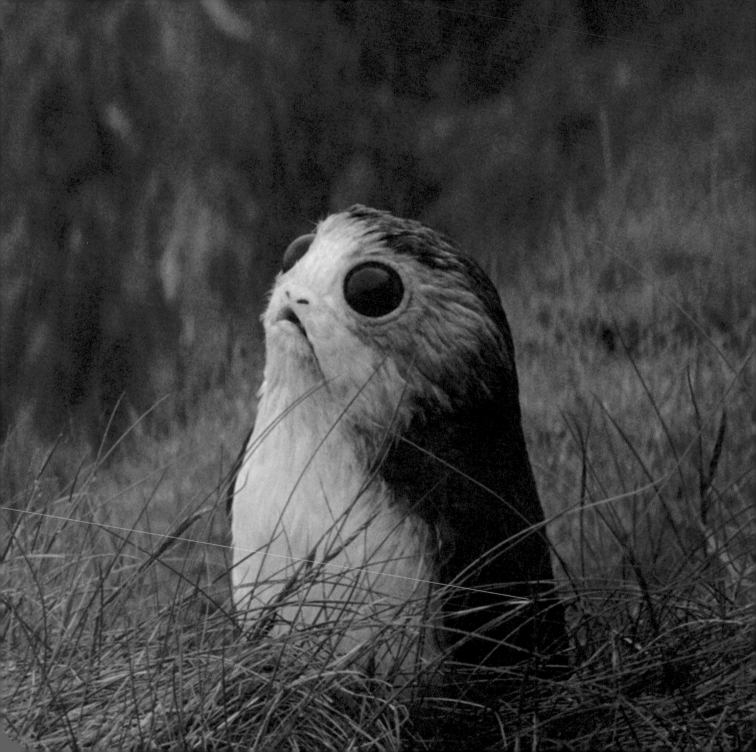

PORG

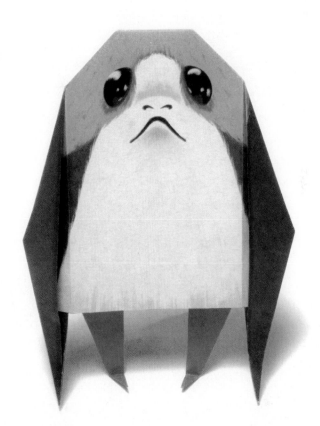

Porgs were small aquatic birds native to the islands on the planet Ahch-To. The feathers around their face and chest were white, blending to a gray-brown on their back. The males had an orange patch around the eyes and were slightly taller than the females. An adult porg stood a little less than a foot tall. When young, the porglets resembled cute balls of light tan feathers with a face.

Although porgs were not great flyers, they could run very quickly on land. Porgs were excellent swimmers and fed on small fish and crustaceans.

HOW TO FOLD: PORG

1 Start colored side up. Valley fold and unfold, then turn over.

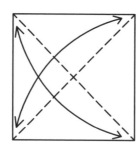

2 Valley fold and unfold.

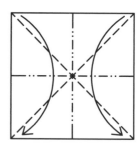

3 Fold into a waterbomb base.

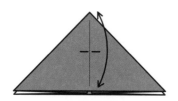

4 Mark fold.

5 Mark fold.

6 Valley fold.

7 Valley fold even with the top corners.

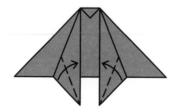

8 Valley fold.

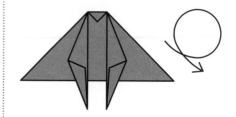

9 Turn over.

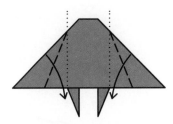

10 Valley fold even with the legs.

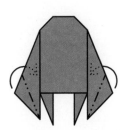

11 Mountain fold.

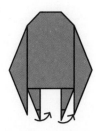

12 Valley fold about a third of the way to make feet.

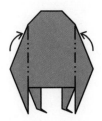

13 Bend the wings back.

14 Finished porg.

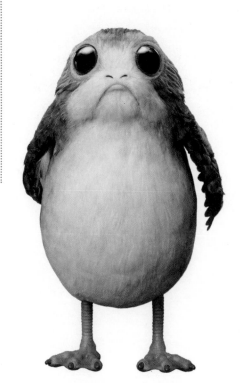

T-16 SKYHOPPER

The T-16 skyhopper was a two-seat craft powered by an ion engine and two repulsorlift generators. It was extremely fast and maneuverable yet easy to fly. It was usually armed with a simple stun cannon.

Luke Skywalker raced his skyhopper against his friends in the twisting canyons of Tatooine. Sometimes they would run across and stun womp rats while flying. Little did Luke know how valuable this training would be years later as he made his attack run against the Empire's Death Star.

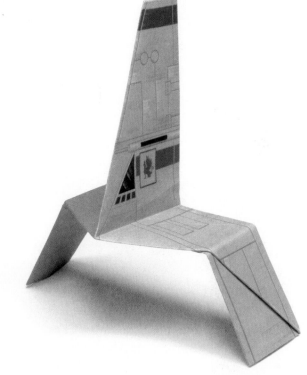

HOW TO FOLD: T-16 SKYHOPPER

1 Start colored side down. Valley fold and unfold.

2 Valley fold.

3 Valley fold.

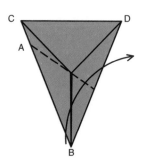

4 Valley fold so edge AB is parallel to edge CD.

5 Unfold.

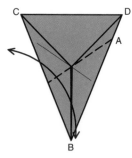

6 Valley fold so edge AB is parallel to edge CD. Unfold.

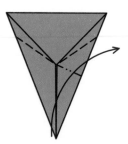

7 Rabbit ear fold.

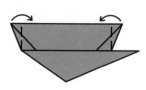

8 Valley fold.

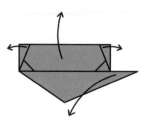

9 Unfold to step 3.

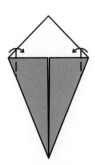

10 Valley fold on the existing crease.

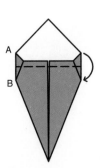

11 Valley fold corner A to corner B.

12 Valley fold just above the hidden crease.

13 Valley fold just above the hidden crease.

14 Rabbit ear fold.

15 Valley fold and unfold.

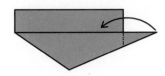

16 Reverse fold.

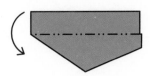

17 Mountain fold.

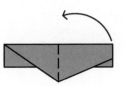

18 Lift the top flap upright.

HOW TO FOLD: T-16 SKYHOPPER (CONT.)

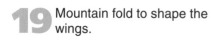

19 Mountain fold to shape the wings.

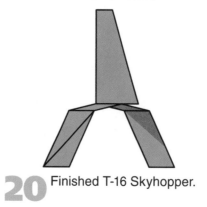

20 Finished T-16 Skyhopper.

TEST YOUR STAR WARS IQ:
MATCHUP

Can you match each droid to its name?

1. 2-1B **2.** K-2SO **3.** R4-P17

4. EV-9D9 **5.** L3-37 **6.** TC-14

A.

B.

C.

D.

E.

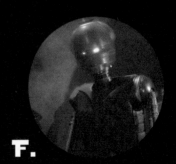

F.

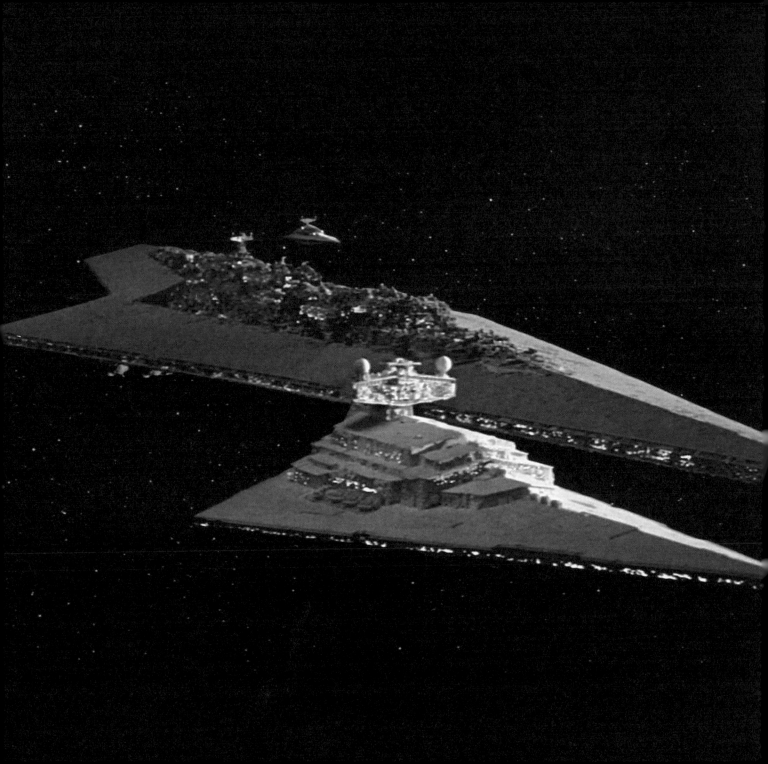

SUPER STAR DESTROYER, THE *EXECUTOR*

Super Star Destroyers were among the most powerful vessels in the Imperial fleet. Their hulls were covered with more than 5,000 laser cannons, turbo lasers, ion cannons, tractor beams, and other weapons systems. They also housed more than 1,000 TIE fighters, TIE bombers, and other starfighters in their many hangar bays.

The Super Star Destroyer *Executor* was Darth Vader's flagship. While under the command of Admiral Ozzel, the *Executor* led the assault on the rebel base on Hoth. It also played a prominent role in the Battle of Endor under the command of Admiral Piett.

HOW TO FOLD: SUPER STAR DESTROYER, THE EXECUTOR

1 Start colored side down. Valley fold and unfold.

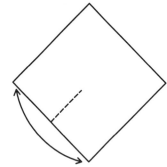

2 Mark fold.

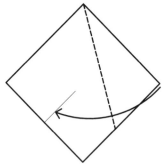

3 Valley fold.

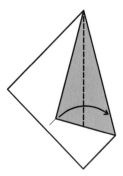

4 Valley fold.

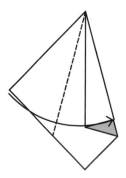

5 Repeat steps 3 and 4 on the left side.

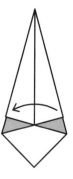

6 Unfold the top flap.

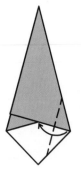

7 Valley fold the corner to the intersection.

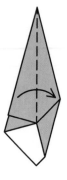

8 Valley fold both flaps.

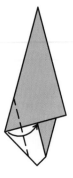

9 Valley fold the corner to the intersection.

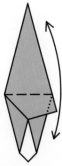

10 Mark fold.

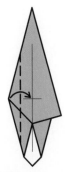

11 Valley fold.

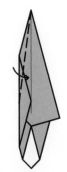

12 Valley fold.

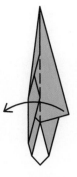

13 Valley fold both flaps.

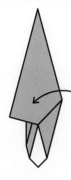

14 Repeat steps 11 and 12 on the right side.

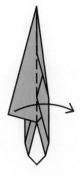

15 Valley fold the top flap.

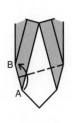

16 Valley fold corner A to corner B.

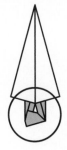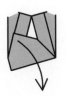

17 Unfold.

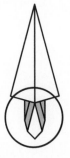

18 Valley fold corner A to corner B.

HOW TO FOLD: SUPER STAR DESTROYER, THE EXECUTOR (CONT.)

19 Valley fold on the crease formed in step 16.

20 Turn over.

21 Finished Super Star Destroyer, the *Executor*.

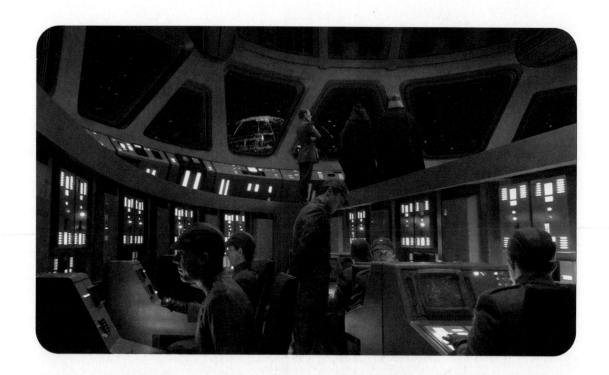

TEST YOUR STAR WARS IQ:

WHO SAID IT?

Match the quote to the correct *Star Wars* character.

1. "I didn't know there was this much green in the whole galaxy."

2. "Congratulations. You are being rescued. Please do not resist."

3. "Twice the pride, double the fall."

4. "It's not my fault!"

5. "So this is how liberty dies— with thunderous applause."

6. "So who talks first? You talk first? I talk first?"

7. "That's how rebellions are born."

8. "Why do I get the feeling you're going to be the death of me?"

9. "You can't wipe them off, they're holograms."

10. "Your son is gone. He was weak and foolish like his father, so I destroyed him."

A. Poe Dameron

B. Count Dooku

C. Obi-Wan Kenobi

D. K-2SO

E. Jyn Erso

F. Rey

G. Kylo Ren

H. Han Solo

I. Tobias Beckett

J. Padmé Amidala

ANSWERS: 1.F, 2.D, 3.B, 4.H, 5.J, 6.A, 7.E, 8.C, 9.I, 10.G

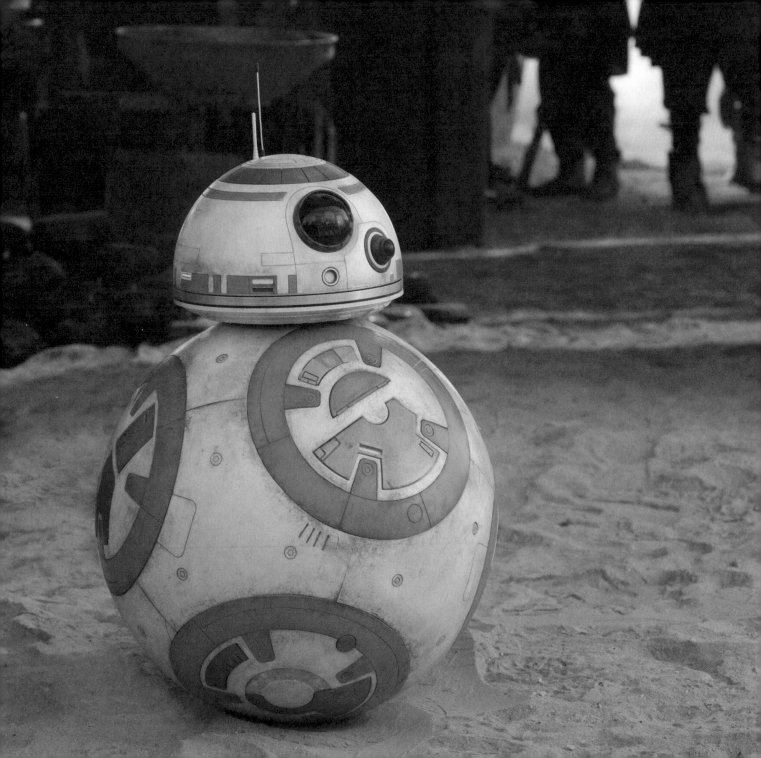

BB-8

Astromech BB-8 was Poe Dameron's trusty companion. Like all astromechs, his primary roles in a starfighter were navigation and dealing with secondary tasks, freeing the pilot to concentrate on the situation at hand. During dogfights, these droids could handle power and shield distribution, minor repairs, and combat coordination.

This particular little droid had an almost childlike innocence, yet was fiercely loyal to Poe. So much, in fact, that when Poe was about to be captured by the First Order, he entrusted BB-8 with part of the map leading to Luke Skywalker's location and counted on the droid to deliver it to leaders of the Resistance.

HOW TO FOLD: BB-8

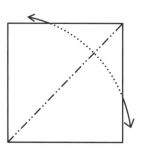

1 Start colored side down. Mountain fold and unfold.

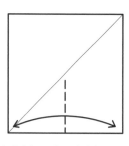

2 Mark fold and unfold.

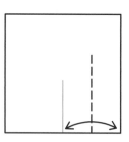

3 Mark fold and unfold.

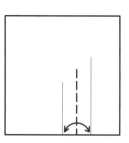

4 Mark fold and unfold.

5 Valley fold and unfold.

6 Valley fold through the creases formed in steps 1 and 5.

7 Mountain fold and unfold.

8 Collapse similar to a preliminary base.

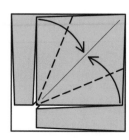

9 Valley fold.

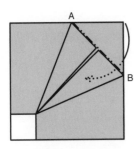

10 Mountain fold along edge AB.

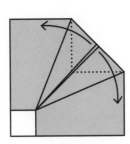

11 Unfold.

12 Unfold and refold along the existing creases.

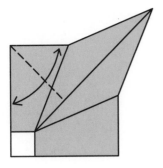

13 Mark fold the top flap.

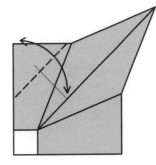

14 Mark fold.

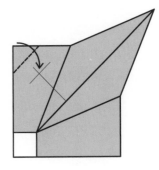

15 Valley fold.

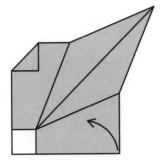

16 Repeat steps 13 through 15 on the other corner.

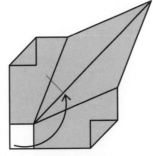

17 Using the mark formed in step 13 as a guide, then repeat steps 14 and 15 on the last corner.

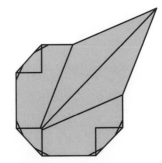

18 Use valley folds on the indicated corners to round out the model.

HOW TO FOLD: BB-8 (CONT.)

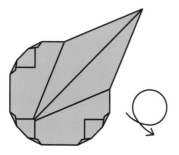

19 Turn over.

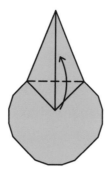

20 Valley fold.

21 Valley fold.

22 Valley fold.

23 Unfold to step 20.

24 Valley fold to crease AB.

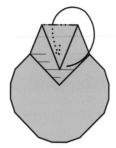

25 Fold the flap all the way to the back of the model.

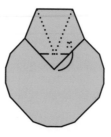

26 Mountain fold on the crease formed in step 21.

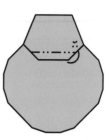

27 Mountain fold on the crease formed in step 22.

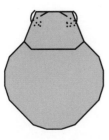

28 Mountain fold the corners to round out the head.

29 Mountain fold the corners trapped between the two layers.

30 Finished BB-8.

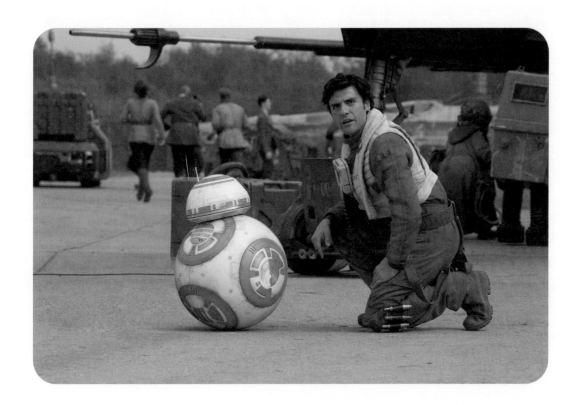

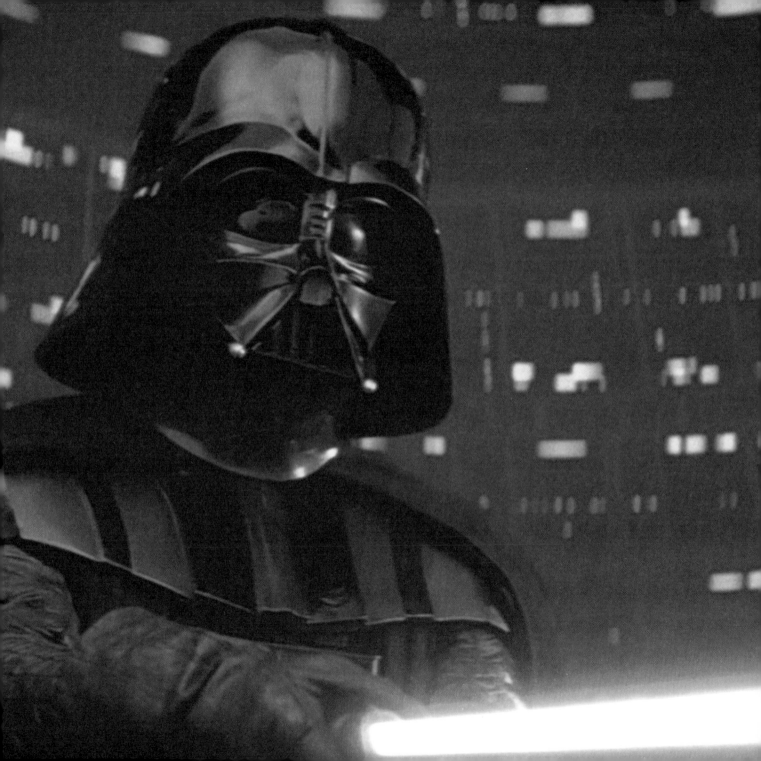

DARTH VADER

Darth Vader was born on Tatooine as Anakin Skywalker. Anakin trained with Obi-Wan Kenobi and became a powerful Jedi Knight. This brought him to the attention of Darth Sidious, who seduced him to the dark side of the Force. Anakin gave up his Jedi connections and became Darth Vader, Dark Lord of the Sith. With Vader's help Sidious destroyed the Jedi Order, disbanded the Republic, and established the Empire in its place.

Darth Sidious, as Emperor Palpatine, ruled the galaxy with Vader as his apprentice. Vader enforced the will of the Emperor, believing peace and stability were more important than personal freedoms. When the Emperor's plans to crush the Rebel Alliance were about to be completed, Vader was forced to choose between serving the Emperor and saving the life of his son, Luke Skywalker. Vader chose to kill the Emperor, thus redeeming himself before becoming one with the Force.

HOW TO FOLD: DARTH VADER

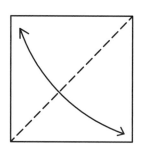

1 Start colored side down. Valley fold and unfold.

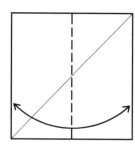

2 Valley fold and unfold.

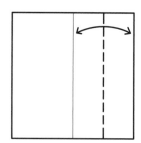

3 Valley fold and unfold.

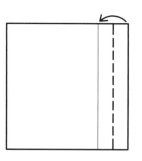

4 Mountain fold.

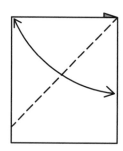

5 Valley fold and unfold.

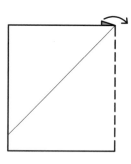

6 Unfold.

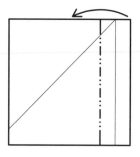

7 Mountain fold.

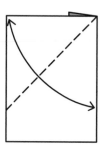

8 Valley fold and unfold.

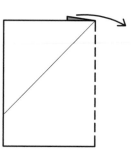

9 Unfold.

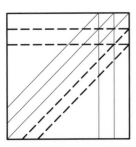

10 Repeat steps 3 through 9 on the top half.

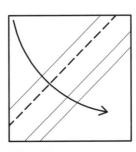

11 Valley fold on the crease formed in step 5.

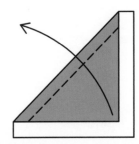

12 Valley fold on the crease formed in step 7.

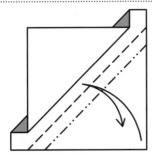

13 Repeat steps 11 and 12 on the bottom.

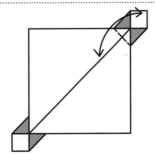

14 Valley fold and unfold.

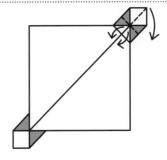

15 Fold the small triangles down while pinching the sides together.

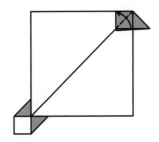

16 Squash fold.

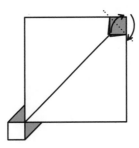

17 Swivel the colored area to the other side.

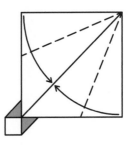

18 Valley fold.

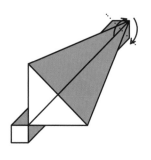

19 Swivel fold as in step 17.

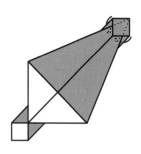

20 Mountain fold the bottom flaps.

21 Valley fold underneath the two upper flaps.

22 Valley fold on the existing crease. Unfold.

23 Mountain fold and unfold.

24 Partially open the top flaps.

25 Pleat on the creases formed in steps 19 and 20.

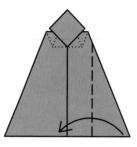

26 Valley fold on the existing crease.

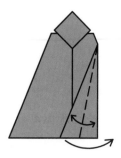

27 Valley fold and unfold to step 26.

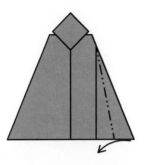

28 Reverse fold on the crease formed in step 27.

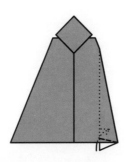

29 Reverse fold the triangle into the model.

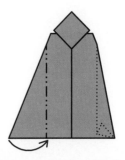

30 Repeat steps 26 through 29 on the left.

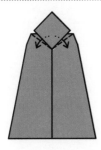

31 Valley fold the two covered flaps.

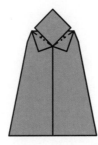

32 Reverse fold the creases formed in step 31.

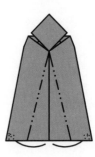

33 Mountain fold.

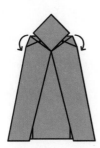

34 Mountain fold the shoulders.

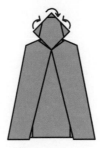

35 Mountain fold to shape the helmet.

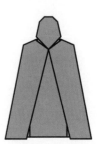

36 Finished Darth Vader.

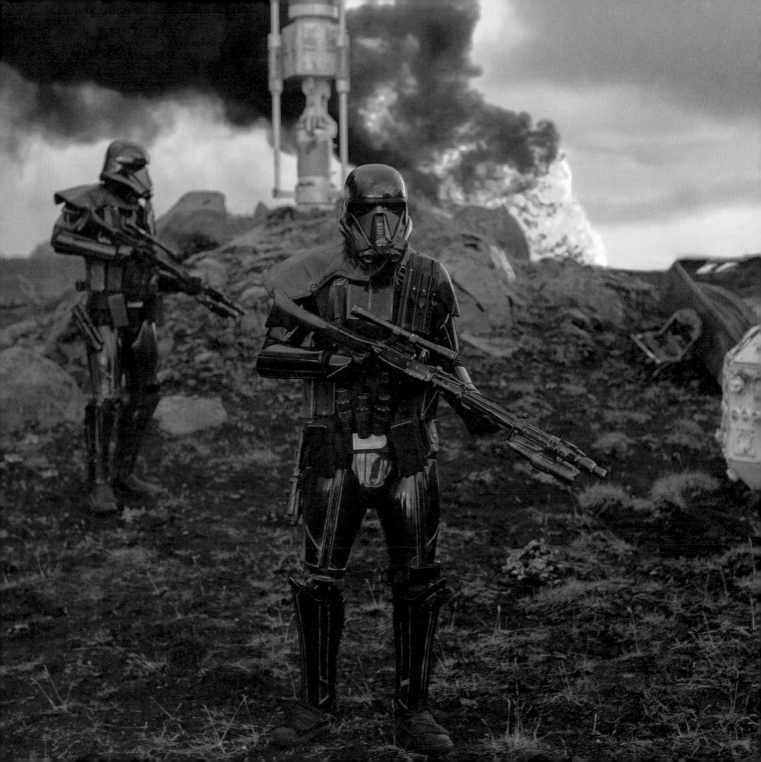

DEATH TROOPER HELMET

Death troopers were an elite branch of Imperial stormtroopers with specialized training in unarmed combat, stealth, reconnaissance, espionage, and demolition. They were experts in scouting, raiding, and small-unit tactics. As a division of the Imperial intelligence branch, they also served as bodyguards for high-ranking officers and political dignitaries.

They wore a black stealth variant of stormtrooper armor with special upgrades. Among those were voice scramblers, motion detectors, friend-or-foe identification systems, and targeting augmentations.

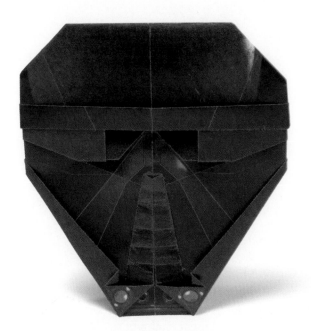

HOW TO FOLD: DEATH TROOPER HELMET

1 Start colored side down. Valley fold and unfold.

2 Valley fold and unfold.

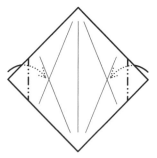

3 Mountain fold to the intersections formed in step 2.

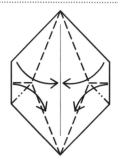

4 Rabbit ear fold. Repeat on the right.

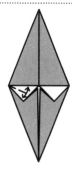

5 Valley fold and unfold. Repeat on the right.

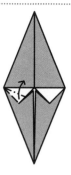

6 Squash fold. Repeat on the right.

7 Pull out the top section as far as it will go. Repeat on the right.

8 Valley fold.

9 Valley fold halfway between point A and edge B.

10 Valley fold even with the centerline AB.

11 Valley fold to the centerline.

12 Valley fold even with points AB.

13 Unfold to step 11.

14 Mountain fold as far as crease AB, and unfold. Repeat on the right.

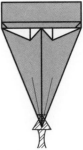

15 Sink fold.

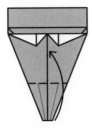

16 Refold on the existing crease.

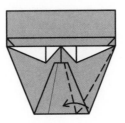

17 Squash fold. Repeat on the left.

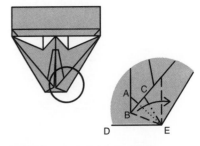

18 Squash fold so ABC becomes a straight line parallel to edge ED.

HOW TO FOLD: DEATH TROOPER HELMET (CONT.)

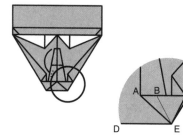

19 Mountain fold in half and unfold.

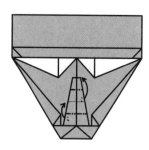

20 Mountain fold in fourths and unfold.

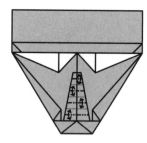

21 Mountain fold in eighths and unfold.

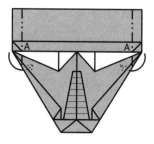

22 Mountain fold. Use point A as the guide.

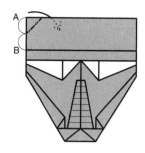

23 Mountain fold. The crease starts halfway between points A and B. Repeat on the right.

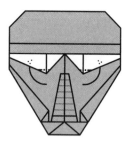

24 Mountain fold just enough to round out the eyes.

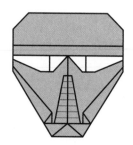

25 Finished Death Trooper Helmet.

TEST YOUR ⭐STAR WARS IQ:
MATCHUP

Where can you find each *Star Wars* creature?

1. Bantha

2. Kaadu

3. Lava flea

4. Mynock

5. Porg

6. Steelpeckers

7. Summa-verminoth

8. Dragonsnake

9. Tauntaun

10. Vexis snake

A. Akkadese Maelstrom

B. Dagobah

C. Asteroid field

D. Naboo

E. Pasaana

F. Jakku

G. Hoth

H. Tatooine

I. Ahch-To

J. Mustafar

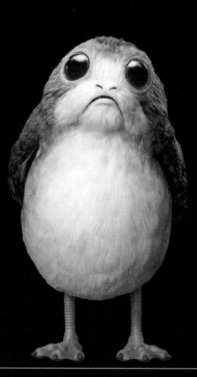

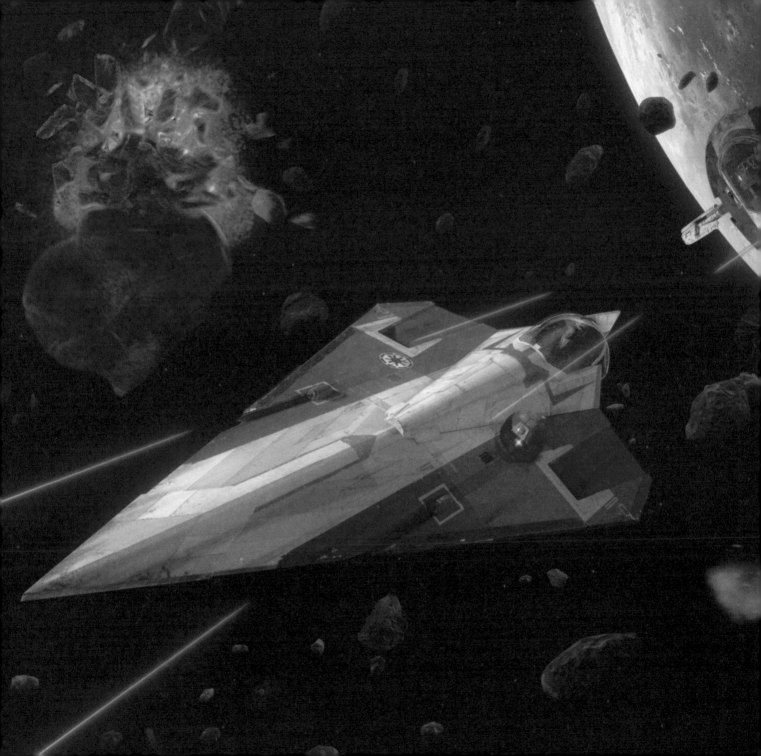

OBI-WAN KENOBI'S JEDI STARFIGHTER

The Delta-7 light interceptor, nicknamed the Jedi starfighter, was the preferred vehicle among the Jedi Knights at the start of the Clone Wars. This ship was known more for its maneuverability and speed than for its firepower. While it did have offensive weapons, the Jedi preferred to use the Force and diplomatic means to avoid confrontations. The Delta-7 had a slot on its port-side wing for an astromech that managed hyperspace navigation, and supplementary scanning and communication mechanisms. These starfighters were too small to hold a hyperdrive, so they relied on a separate booster ring to travel from system to system. On arrival, the ring detached and floated in space until the fighter docked with it for the return trip.

HOW TO FOLD: OBI-WAN KENOBI'S JEDI STARFIGHTER

1 Start colored side down. Valley fold and unfold.

2 Mark fold.

3 Valley fold.

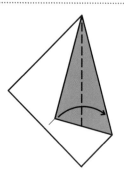

4 Valley fold.

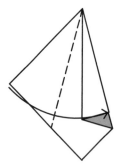

5 Repeat steps 3 and 4 on the left side.

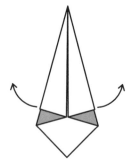

6 Unfold to step 3.

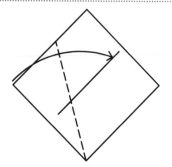

7 Valley fold.

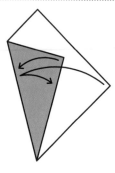

8 Repeat steps 4 and 5 on the bottom of the model.

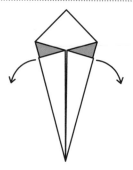

9 Unfold to step 3.

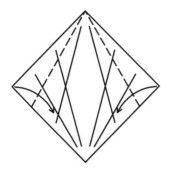

10 Valley fold.

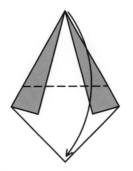

11 Valley fold.

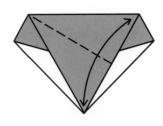

12 Valley fold and unfold.

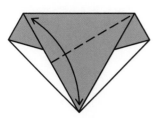

13 Valley fold and unfold.

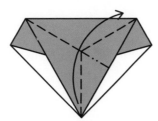

14 Rabbit ear fold.

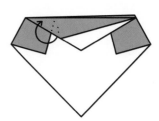

15 Pull the hidden paper out and refold. Repeat on the right.

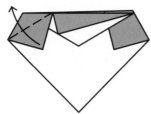

16 Valley fold. Repeat on the right.

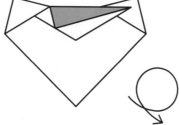

17 Turn over.

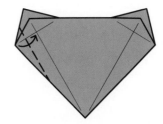

18 Valley fold. Repeat on the right.

19 Valley fold. Repeat on the right.

20 Valley fold. Repeat on the right.

21 Turn over.

22 Valley fold on the existing crease. Repeat on the right.

23 Mountain fold into the center pocket. Repeat on the right.

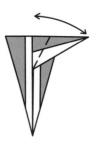

24 Valley fold and unfold.

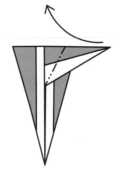

25 Squash fold.

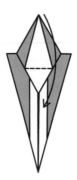

26 Petal fold.

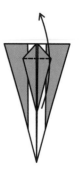

27 Valley fold.

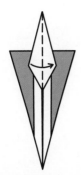

28 Valley fold.

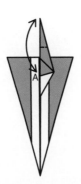

29 Valley fold to point A and unfold.

30 Reverse fold.

31 Stand the cockpit up.

32 Finished Obi-Wan Kenobi's Jedi starfighter.

SEBULBA'S PODRACER

S ebulba was a famous podracer and notorious cheater. His orange craft featured two huge split-x engines held together by a plasma energy binder, while the cockpit was towed behind the engines on Steelton cables. The engines were loud, intimidating, and, of course, fitted with illegal flamethrowers. Sebulba liked to win, and if he had to torch, smash, ram, or toss slag into the engines of other racers, it was the price they would have to pay so he could cross the finish line first.

HOW TO FOLD: SEBULBA'S PODRACER

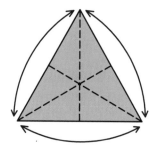

1 Start with an equilateral triangle, colored side up. Valley fold and unfold.

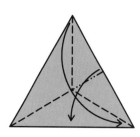

2 Rabbit ear fold.

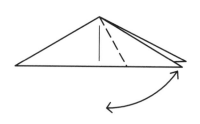

3 Valley fold and unfold.

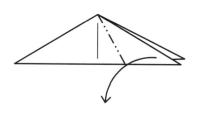

4 Squash fold.

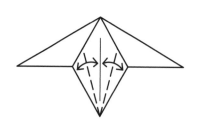

5 Valley fold and unfold.

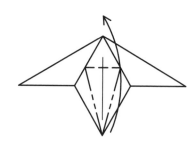

6 Petal fold.

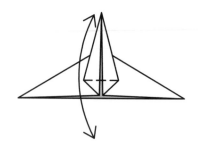

7 Valley fold and unfold.

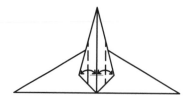

8 Valley fold and unfold.

9 Mountain fold.

10 Turn over.

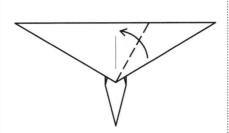

11 Valley fold.

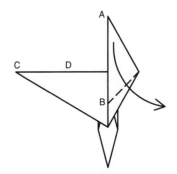

12 Valley fold so edge AB is parallel to edge CD.

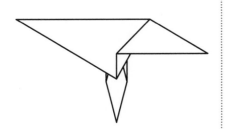

13 Unfold to step 11.

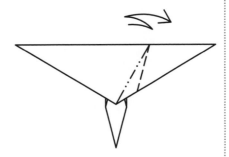

14 Pleat fold on the creases formed in steps 11 and 12.

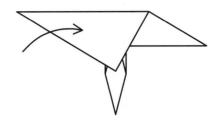

15 Repeat steps 11 through 14 on the left.

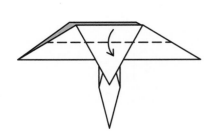

16 Valley fold.

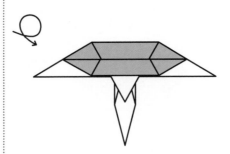

17 Turn over.

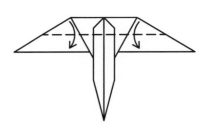

18 Valley fold.

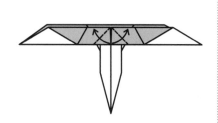

19 Valley fold.

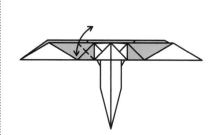

20 Valley fold and unfold.

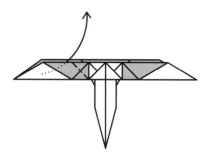

21 Reverse fold.

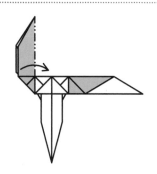

22 Unfold.

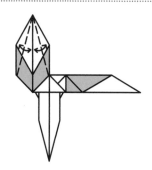

23 Valley fold and unfold.

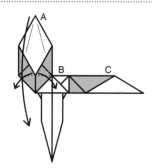

24 Valley fold point A down, while spreading the colored flaps out.

25 Reverse fold on the existing creases.

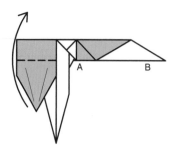

26 Valley fold even with edge AB.

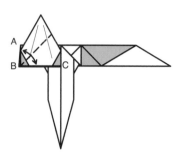

27 Valley fold edge AB to edge BC. Unfold.

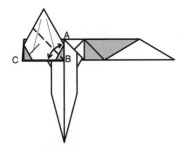

28 Valley fold edge AB to edge CB. Unfold.

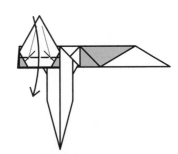

29 Valley fold through the intersection of the existing creases.

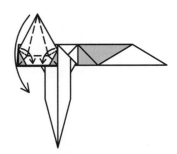

30 Collapse on the existing creases with two rabbit ear folds.

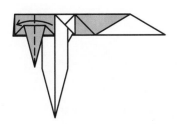

31 Valley fold.

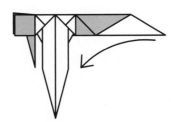

32 Repeat steps 20 through 31 on the right side.

33 Valley fold and unfold.

34 Sink fold.

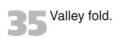

35 Valley fold.

36 Valley fold.

HOW TO FOLD: SEBULBA'S PODRACER (CONT.)

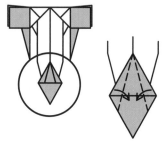
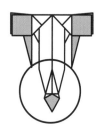
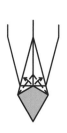

37 Valley fold.

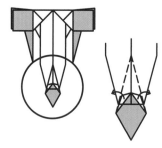

38 Valley fold.

39 Valley fold.

40 Finished Sebulba's podracer.

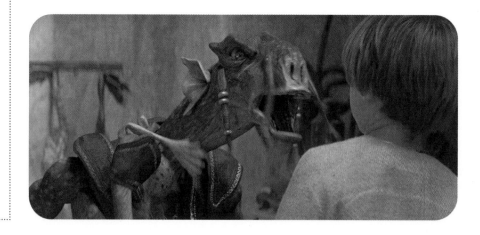

TEST YOUR ⭐ STAR WARS IQ:
MATCHUP

Match the *Star Wars* character to his or her home planet.

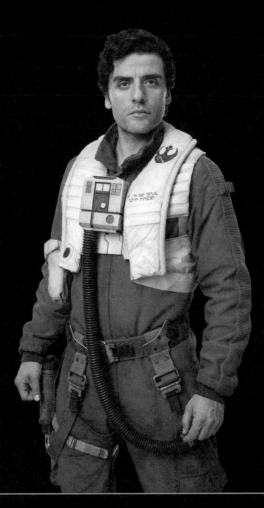

1. Padmé Amidala

2. Chewbacca

3. Anakin Skywalker

4. Boba Fett

5. Poe Dameron

6. Leia Organa

7. Han Solo

A. Tatooine

B. Yavin 4

C. Alderaan

D. Kamino

E. Naboo

F. Corellia

G. Kashyyyk

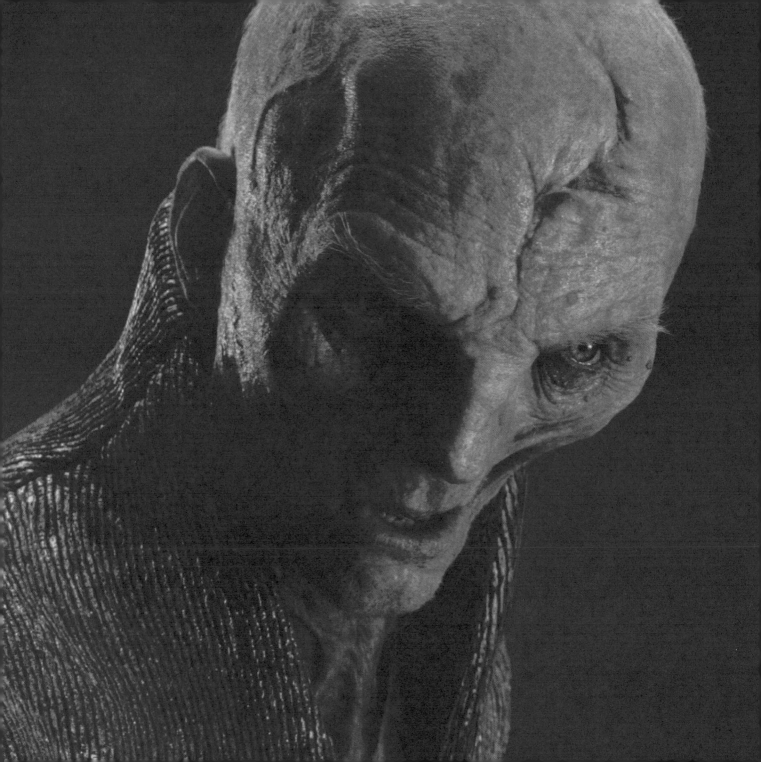

SUPREME LEADER SNOKE

Supreme Leader Snoke was a student of the dark side of the Force. He used his abilities to gather the remnants of the Empire and restructure it as the First Order. Even though he wasn't a Sith, Snoke followed many of their tenets. And, like Palpatine before him, Snoke saw the Jedi as a threat to his consolidation of power. If he could destroy Luke Skywalker and his Jedi students, then no one would be left to stand in his way.

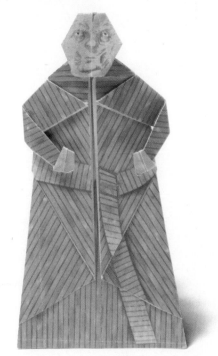

One of those students was Ben Solo, son of Han Solo and Leia Organa, and grandson of Darth Vader. Snoke saw Ben's dark side potential and managed to lure him away from the light. Ben eventually took the name Kylo Ren. Snoke was destroyed by his young apprentice aboard his *Mega*-class Star Dreadnought, the *Supremacy*.

HOW TO FOLD: SUPREME LEADER SNOKE

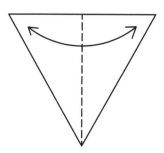

1 Start with an equilateral triangle, colored side down. Valley fold and unfold.

2 Valley fold and unfold.

3 Valley fold and unfold. Repeat on the left.

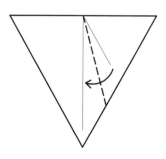

4 Valley fold.

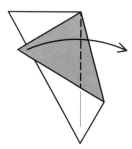

5 Valley fold.

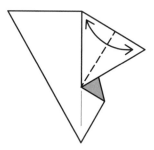

6 Valley fold and unfold.

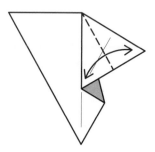

7 Valley fold and unfold.

8 Rabbit ear fold.

9 Valley fold.

10 Unfold.

11 Repeat steps 4 through 10 on the left side.

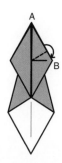

12 Valley fold even with edge AB. Repeat on the left.

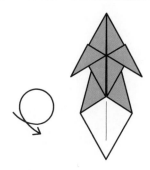

13 Turn over.

14 Valley fold while adding a squash fold at A. Repeat on the left.

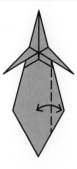

15 Mark fold. Repeat on the left.

16 Valley fold and unfold. Repeat on the left.

17 Turn over.

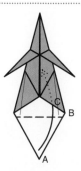

18 Valley fold so edge AB lies on intersection C and the flap is under the colored layers.

19 Mountain fold on the creases formed in step 16.

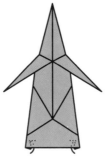

20 Make small valley folds on the exposed corners so they're no longer visible.

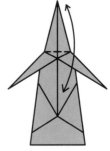

21 Valley fold and unfold.

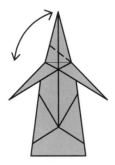

22 Valley fold and unfold. Repeat on the right.

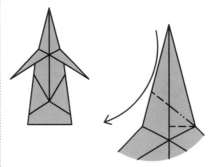

23 Squash fold.

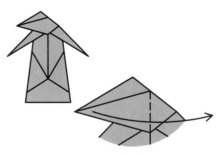

24 Valley fold while pulling out the trapped paper, similar to step 23.

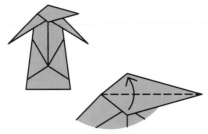

25 Valley fold the top layer.

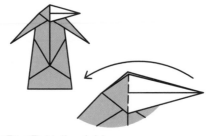

26 Valley fold.

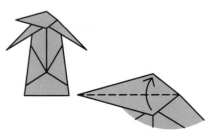

27 Valley fold the top layer.

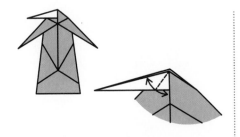

28 Valley fold and unfold.

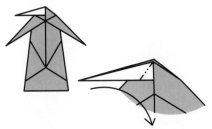

29 Squash fold.

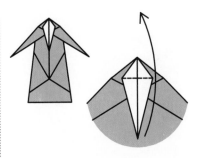

30 Valley fold and unfold.

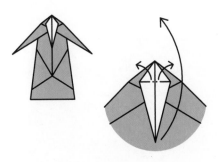

31 Spread the top layers open while folding the point up.

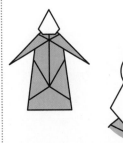

32 Mountain fold about a third of the way down.

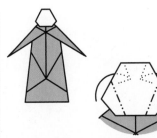

33 Mountain fold to thin the cheeks. There are no guide folds for this step.

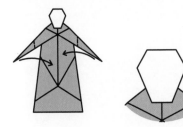

34 Valley fold to form elbows.

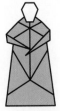

35 Spread open the bottom-most pocket and squash fold to form a hand. There is no guide fold for this step.

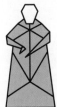
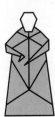

36 Valley fold.

HOW TO FOLD: SUPREME LEADER SNOKE (CONT.)

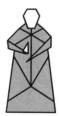 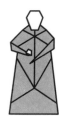 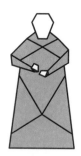

37 Mountain fold about a third of the way down.

38 Repeat steps 35 through 37 on the other hand.

39 Finished Supreme Leader Snoke.

TEST YOUR STAR WARS™ IQ:
TRUE OR FALSE

1. George Lucas never appeared in any of the *Star Wars* movies.

2. Ben Solo is related to Shmi.

3. There are only three colors of lightsaber blade: red, blue, and green.

4. The *Millennium Falcon* has had at least four different rectennas (radar dishes).

5. Wedge Antilles flew an X-wing in the battles against both Death Stars.

6. Boba Fett's helmet rangefinder is on his left side.

7. Warwick Davis has a cameo in every *Star Wars* movie released since *Return of the Jedi*.

8. Darth Vader always used a red lightsaber.

ANSWERS: 1. False. 2. True. 3. False. 4. True. 5. True. 6. False. 7. False. 8. True.

79

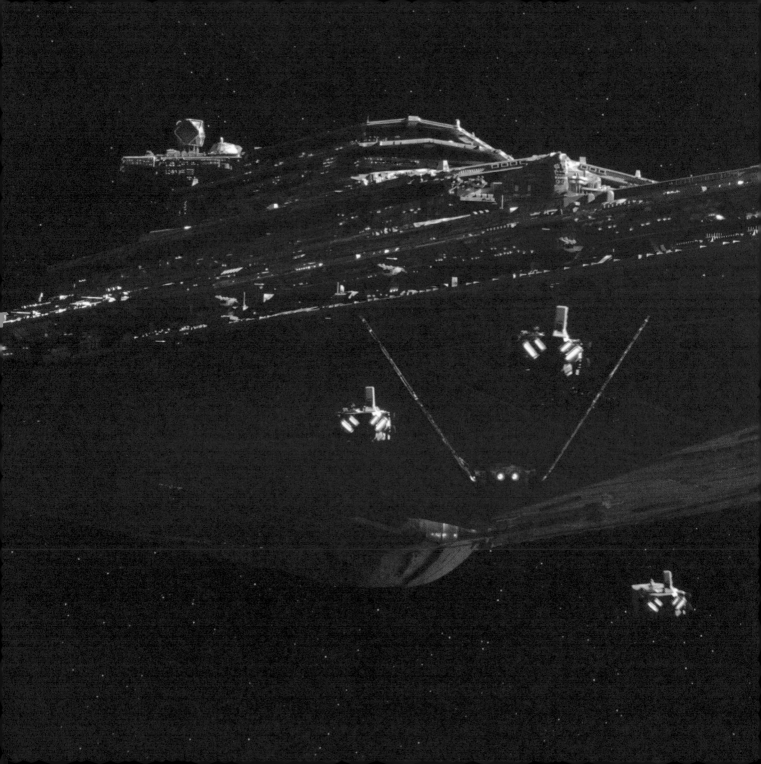

FIRST ORDER STAR DESTROYER, THE *FINALIZER*

The *Resurgent*-class Star Destroyer was the latest generation of First Order battle cruisers. Although based on the time-proven Star Destroyer design, it was almost 3,000 meters long, more than two times larger than the first-generation *Venator*-class Star Destroyer. The *Finalizer* had a crew of more than 82,000 and two full starfighter wings. With more than 1,500 turbolasers, laser batteries, and ion cannons, they could handle multiple roles in any battle theater. Part starfighter carrier, part battle cruiser, and part mobile command base, these ships were fully capable of suppressing any star system and bringing it in line with the First Order's new regime.

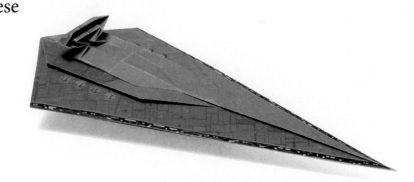

HOW TO FOLD: FIRST ORDER STAR DESTROYER, THE *FINALIZER*

1 Start colored side down. Valley fold and unfold.

2 Mark fold.

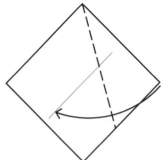

3 Valley fold.

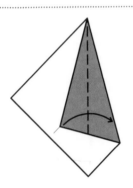

4 Valley fold.

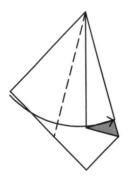

5 Repeat steps 3 and 4 on the left side.

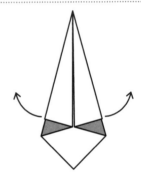

6 Unfold to step 3.

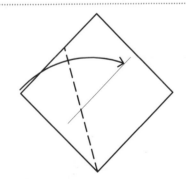

7 Valley fold.

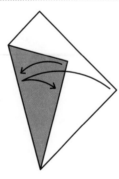

8 Repeat steps 4 and 5 on the bottom of the model.

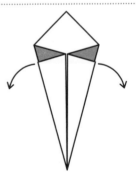

9 Unfold to step 3.

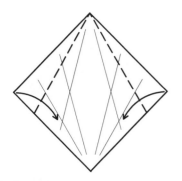

10 Valley fold.

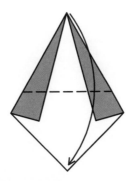

11 Valley fold.

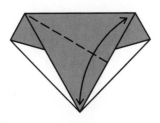

12 Valley fold and unfold.

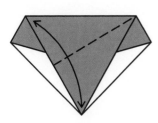

13 Valley fold and unfold.

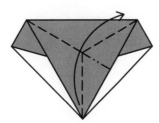

14 Rabbit ear fold.

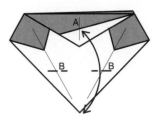

15 Mark fold to point A. Crease at intersection B. Unfold.

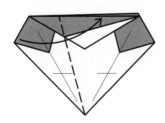

16 Valley fold on the existing crease.

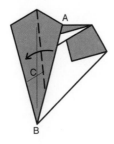

17 Valley fold so edge AB lands on intersection C.

18 Mountain fold.

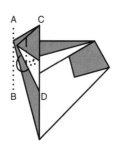

19 Mountain fold halfway between AB and CD.

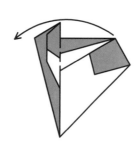

20 Fold the flap to the left.

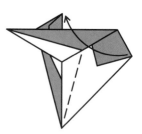

21 Repeat steps 16 through 19 on the right side.

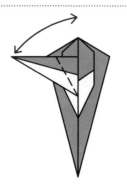

22 Valley fold and unfold.

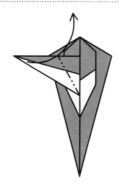

23 Squash fold.

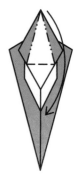

24 Petal fold.

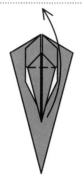

25 Valley fold.

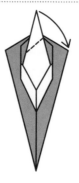

26 Valley fold the tip to the corner.

27 Unfold.

28 Valley fold and unfold.

29 Rabbit ear fold.

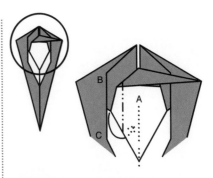

30 Valley fold. Repeat on the right.

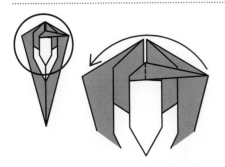

31 Valley fold.

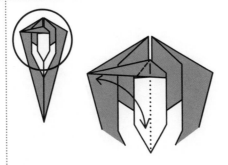

32 Valley fold and unfold.

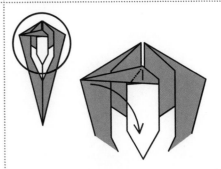

33 Squash fold.

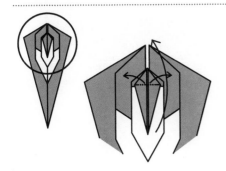

34 Valley fold while spreading the top layers open.

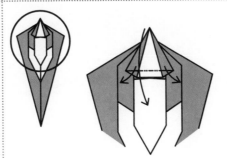

35 Valley fold while spreading the top layers open.

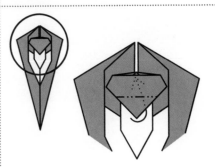

36 Mountain fold in half.

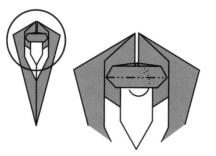

37 Mountain fold in half.

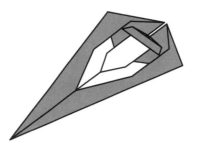

38 Finished First Order Star Destroyer, the *Finalizer*.

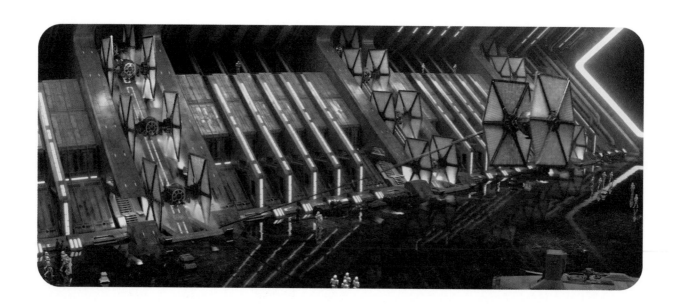

TEST YOUR ~STAR WARS~ IQ:
BB-8 TRUE OR FALSE

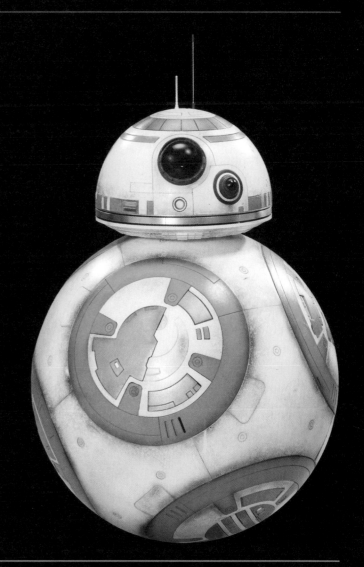

1. Can speak in basic

2. Befriended D-O

3. Has 8 tool bay disks

4. Has a welding torch

5. His paint scheme is common for BB units

6. Is owned by Rey

7. Met Han Solo

8. Met Luke Skywalker

9. Once had a body like R2-D2

ANSWERS: 1. False, 2. True, 3. False, 4. True, 5. False, 6. False, 7. True, 8. False, 9. False

87

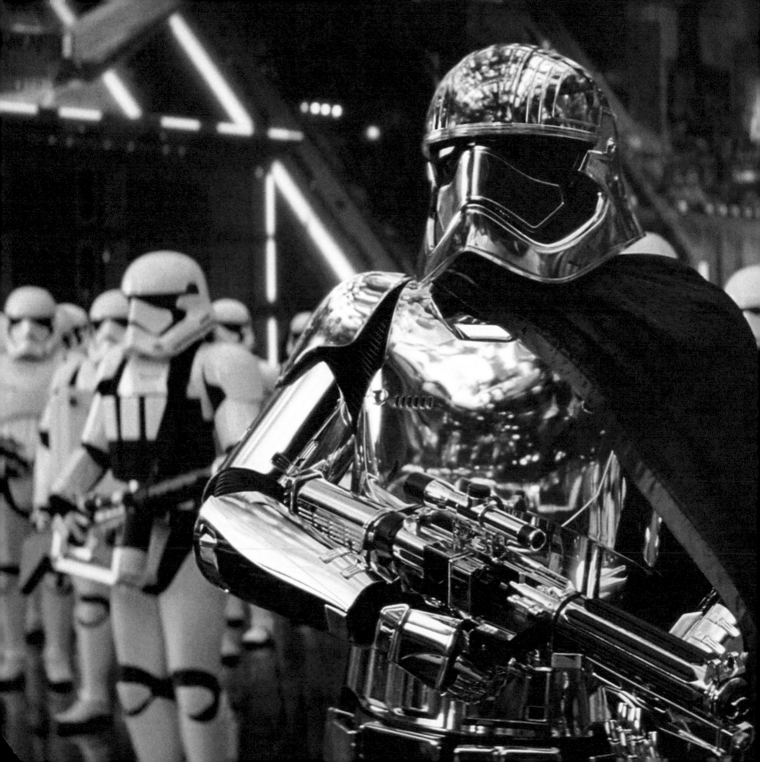

FIRST ORDER STORMTROOPERS

Stormtroopers were the most visible symbol of the might of the First Order. They wore the latest generation of body armor, which had its origins in the Clone Wars. The armor was lighter, stronger, and more versatile than the versions worn during the reign of the Empire.

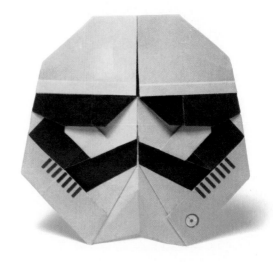

Captain Phasma was one of the three leaders of the First Order, along with Kylo Ren and General Hux. She directed the training and indoctrination of legions of First Order stormtroopers. Her special chromium armor lent an extra air of mystique to her authority. She met her end on the *Supremacy* trying to stop Finn and Rose Tico from escaping.

HOW TO FOLD: FIRST ORDER STORMTROOPERS

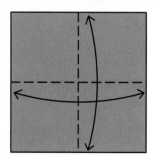

1 Start colored side up. Valley fold and unfold.

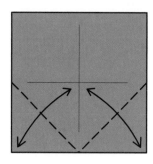

2 Valley fold and unfold.

3 Valley fold and unfold.

4 Valley fold and unfold.

5 Valley fold.

6 Valley fold.

7 Valley fold so crease AB aligns with edge CD.

8 Valley fold on the crease formed in step 6.

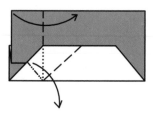

9 Fold on the existing creases.

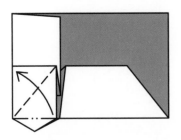

10 Squash fold on the existing creases.

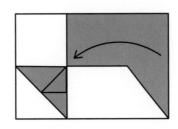

11 Repeat steps 9 and 10 on the right.

12 Valley fold and unfold.

13 Valley fold about a third of the way to the intersection.

14 Valley fold.

15 Mountain fold.

 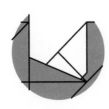

16 Repeat steps 12 through 15 on the left.

17 Mark fold.

18 Valley fold parallel to edge AB. The crease starts halfway between A and mark C.

19 Unfold.

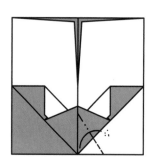

20 Reverse fold.

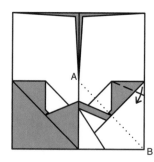

21 Valley fold parallel to AB.

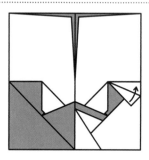

22 Unfold.

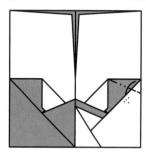

23 Reverse fold.

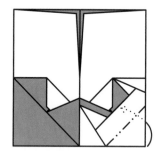

24 Mountain fold.

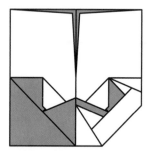

25 Repeat steps 18 through 24 on the left side.

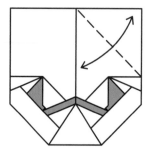

26 Valley fold and unfold.

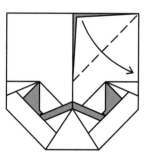

27 Valley fold.

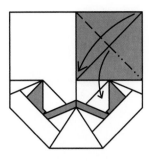

28 Squash fold.

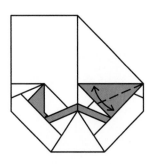

29 Valley fold and unfold.

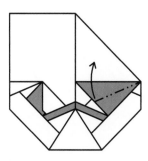

30 Squash fold.

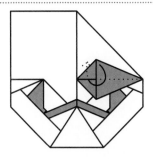

31 Reverse the upper half of the flap under the covered layer.

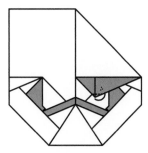

32 Make a small mountain fold to round out the eye.

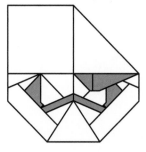

33 Repeat steps 26 through 34 on the left side.

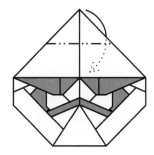

34 Mountain fold.

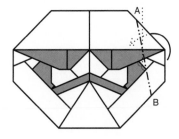

35 Mountain fold. Note the reference points A and B for the crease. Repeat on the left.

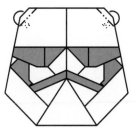

36 Mountain fold to round out the top of the helmet. There are no guide folds for this step.

HOW TO FOLD: FIRST ORDER STORMTROOPERS (CONT.)

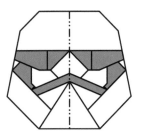

37 Make a slight mountain fold to shape the helmet.

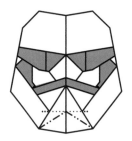

38 Make slight mountain folds to shape the chin.

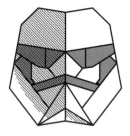

39 Finished First Order Stormtrooper helmet.

USE THESE INSTRUCTIONS TO FOLD ALL THREE HELMETS!

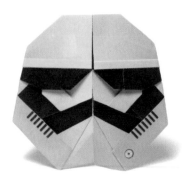

FIRST ORDER STORMTROOPER HELMET

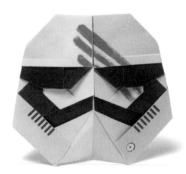

FIRST ORDER STORMTROOPER HELMET FN-2187 (FINN)

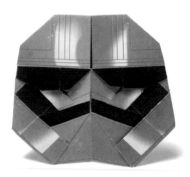

CAPTAIN PHASMA'S HELMET

SITH TROOPER HELMET

Sith troopers were a type of trooper that served under Darth Sidious in his Final Order. Named for the Sith, an ancient religious order of Force-wielders who worshipped the dark side, Sith troopers were the mysterious evolution of the Imperial and First Order stormtroopers. Distinguished by their sinister red armor, Sith troopers were organized into legions of 5,000 soldiers within the Final Order. Each legion was named after an ancient Sith Lord. Many Sith troopers were killed in the Battle of Exegol, the final battle in the war between the First Order and the Resistance, when the Resistance finally defeated the First Order and Darth Sidious' Final Order.

USE THE DIRECTIONS ON PAGE 90 TO FOLD SITH TROOPER HELMET.

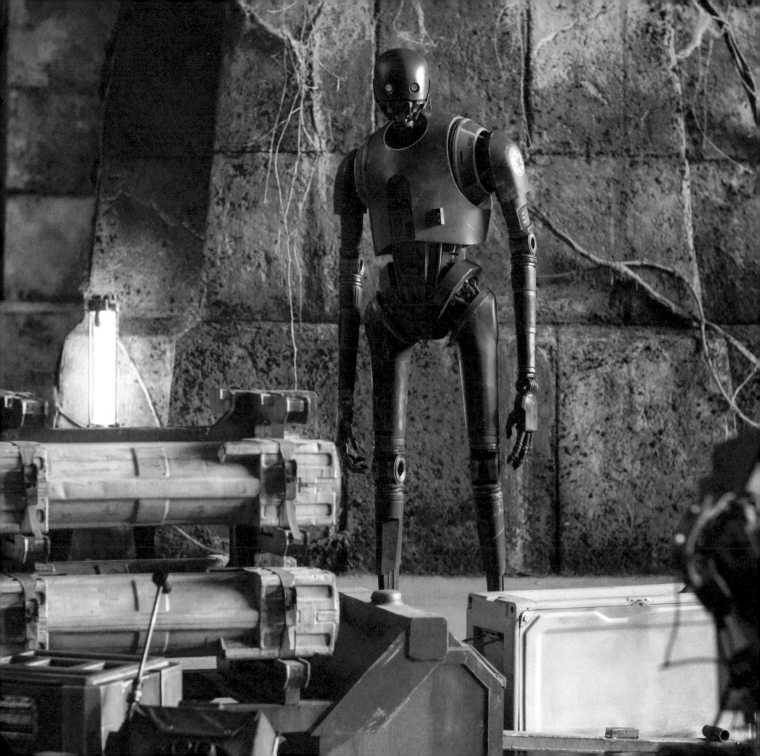

K-2SO

Cassian Andor appropriated K-2SO from the Empire and reprogrammed him to serve the Rebel Alliance. As a result of the reprogramming, K-2SO developed a unique personality for a droid. He was brutally direct and prone to interpreting instructions as he saw fit. He was an important member of the Battle of Scarif to steal the Death Star plans. Sadly, he was destroyed while buying time for Cassian and Jyn Erso to transmit the plans to the rebel fleet.

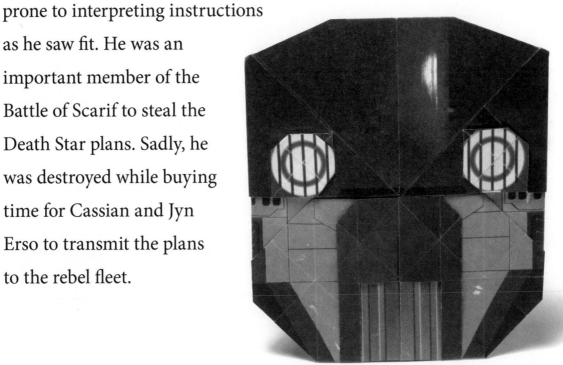

HOW TO FOLD: K-2SO

1 Start colored side down. Valley fold and unfold.

2 Valley fold and unfold.

3 Valley fold and unfold.

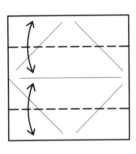

4 Valley fold and unfold.

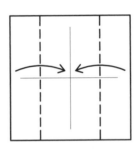

5 Valley fold.

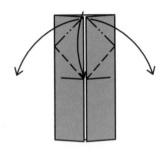

6 Spread the corners outward while folding the top edge down.

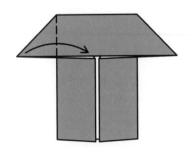

7 Squash fold. Repeat on the right.

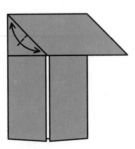

8 Mark fold.

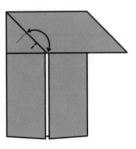

9 Mark fold.

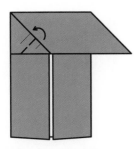

10 Valley fold so the mark formed in step 9 lands on the mark formed in step 8.

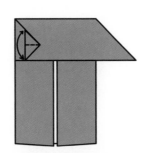

11 Valley fold and unfold.

12 Squash fold.

13 Valley fold about halfway to line AB.

14 Valley fold.

15 Mountain fold the corners about halfway to the center.

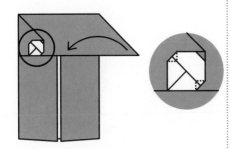

16 Repeat steps 7 through 15 on the right side.

17 Valley fold and unfold.

18 Valley fold and unfold. Repeat on the right.

19 Valley fold and unfold.

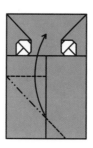

20 Squash fold.

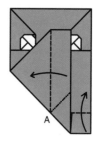

21 Valley fold while adding a squash fold at A.

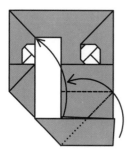

22 Pull out the hidden paper while adding a squash fold similar to step 20.

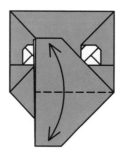

23 Valley fold and unfold.

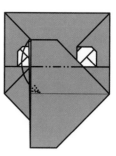

24 Mountain fold the top layer.

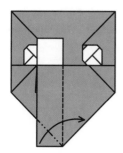

25 Squash fold.

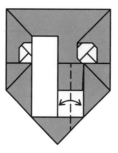

26 Valley fold and unfold.

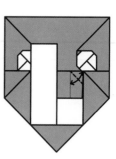

27 Valley fold and unfold.

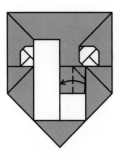

28 Squash fold.

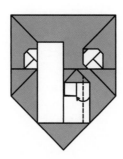

29 Valley fold.

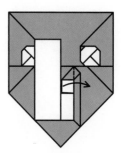

30 Valley fold.

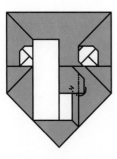

31 Mountain fold under the bottom flap.

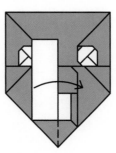

32 Valley fold.

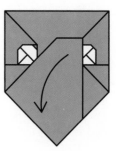

33 Repeat steps 23 through 31 on the left side.

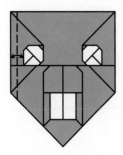

34 Valley fold and unfold.

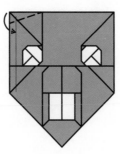

35 Valley fold so the corner lands on the existing crease.

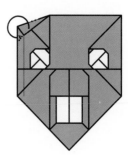

36 Mountain fold to the other side.

HOW TO FOLD: K-2SO (CONT.)

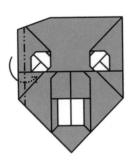

37 Mountain fold on the crease formed in step 34.

38 Repeat steps 34 through 37 on the right side.

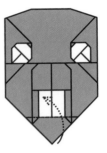

39 Mountain fold.

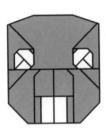

40 Finished K-2SO.

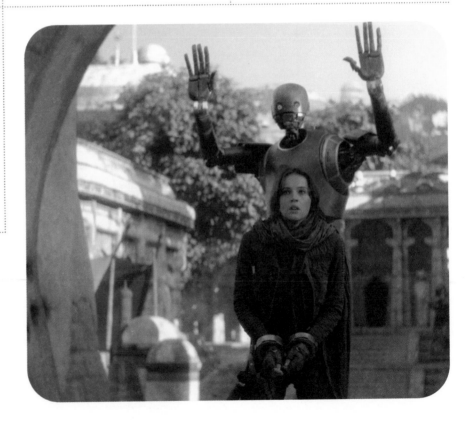

TEST YOUR STAR WARS IQ:
MATCHUP

Match the first sentence of opening crawl with its movie.

1. It is a dark time for the Rebellion.

2. It is a period of civil war.

3. Luke Skywalker has returned to his home planet of Tatooine in an attempt to rescue his friend Han Solo from the clutches of the vile gangster Jabba the Hutt.

4. Luke Skywalker has vanished.

5. There is unrest in the Galactic Senate.

6. Turmoil has engulfed the Galactic Republic.

7. The Dead Speak!

8. The First Order reigns.

9. War!

A. *The Rise of Skywalker*

B. *Attack of the Clones*

C. *The Force Awakens*

D. *The Empire Strikes Back*

E. *A New Hope*

F. *The Phantom Menace*

G. *The Last Jedi*

H. *Return of the Jedi*

I. *Revenge of the Sith*

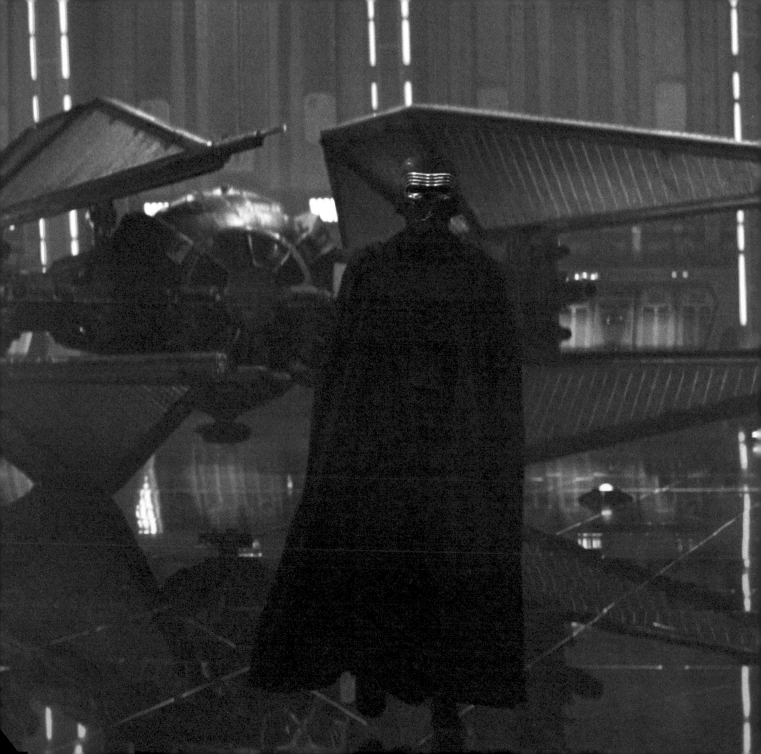

KYLO REN'S TIE WHISPER

Faster, more agile, and with twice the firepower of the standard TIE fighter, the whisper was one of the best Imperial starfighters during the age of the Empire. Its design was based on the TIE Advanced x1, which was made famous by Darth Vader during the Battle of Yavin. In spite of its advantages, it lacked the hyperdrive of the x1, limiting it to short-range sorties and defensive combat roles. During the reign of the First Order, Kylo Ren had a custom interceptor built to his specifications. It was equipped with a hyperdrive as well as extra targeting and weapons packages.

HOW TO FOLD: KYLO REN'S TIE WHISPER

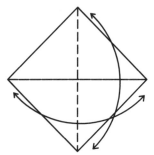

RIGHT WING

1 Start colored side down. Valley fold and unfold.

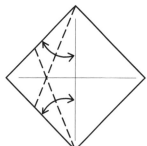

2 Valley fold and unfold on the left side.

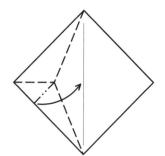

3 Rabbit ear fold.

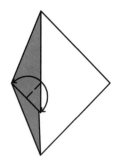

4 Valley fold and unfold.

5 Unfold to step 3.

6 Valley fold.

7 Squash fold.

8 Valley fold the hidden triangle on the crease formed in step 4.

9 Turn over.

10 Repeat steps 2 through 8 on the left side.

11 Valley fold and unfold.

12 Sink fold.

13 Mark fold.

14 Valley fold and unfold.

15 Sink fold.

16 Mountain fold.

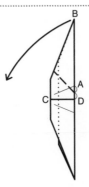

17 Valley fold so edge AB is perpendicular to edge CD.

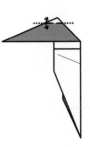

18 Valley fold the white area. Unfold.

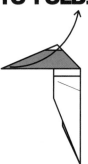

19 Unfold to step 17.

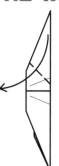

20 Outside reverse fold on the creases formed in step 17.

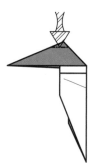

21 Sink fold on the crease formed in step 18.

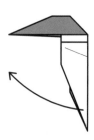

22 Repeat steps 17 through 20 on the bottom half.

23 Completed Right Wing.

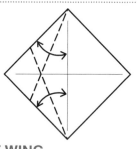

LEFT WING

24 Repeat steps 1 through 9 of Right Wing.

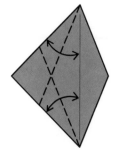

25 Valley fold and unfold.

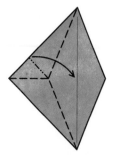

26 Valley fold and unfold.

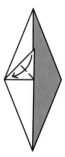

27 Repeat steps 4 through 9 of Right Wing so the pocket points to the top half of the model.

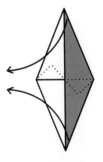

28 Repeat steps 11 through 22 of Right Wing.

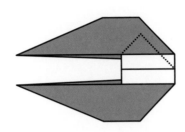

29 Completed Left Wing.

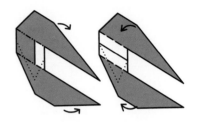

30 Fold Right and Left Wings about 45 degrees.

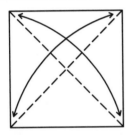

COCKPIT

31 Start with a square three-fourths of the size used for the wings, colored side down. Valley fold and unfold.

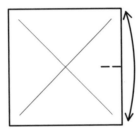

32 Mark fold.

33 Mark fold.

34 Mark fold.

35 Valley fold through the intersection of the creases formed in steps 31 and 34. Unfold.

36 Valley fold and unfold.

HOW TO FOLD: KYLO REN'S TIE WHISPER (CONT.)

37 Valley fold and unfold.

38 Valley fold through the intersection of the creases formed in steps 31, 36, and 37. Unfold.

39 Valley fold the corner to intersection A. Crease only from B to C. Unfold and repeat on the other three corners.

40 Mountain fold and unfold.

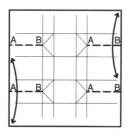

41 Valley fold. Crease only from A to B. Unfold.

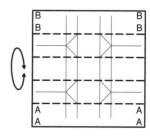

42 Valley fold into a cylinder with section A overlapping section B.

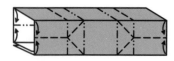

43 Collapse the sides on the existing creases with four rabbit ear folds.

44 Valley fold. Repeat on the right side and on the bottom.

45 Mountain fold about a third of the way in from each end.

46 Finished Cockpit.

ASSEMBLY

47 Insert each flap into the pocket of a solar panel.

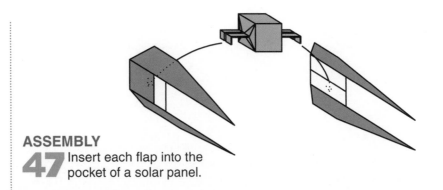

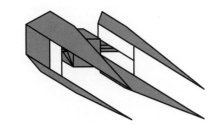

48 Finished Kylo Ren's TIE Whisper.

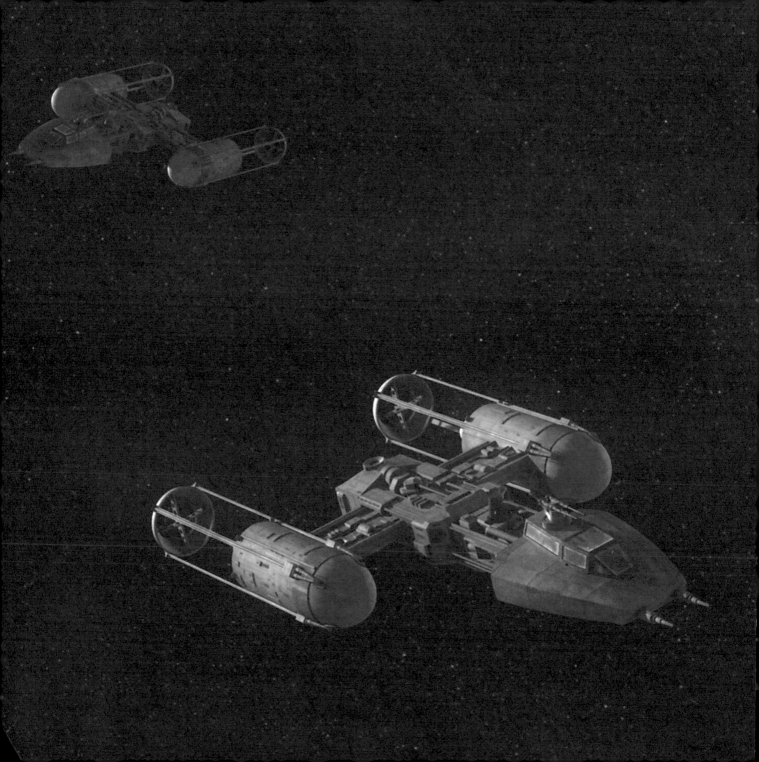

Y-WING

Of all the Rebel Alliance's starfighters, the Y-wing was the oldest, dating back to the Clone Wars. Even though it was slower than the average fighter, it was still an effective part of the fleet. The Y-wing was armed with both twin laser and ion cannons, and it carried a large complement of proton torpedoes. It had strong armor and shields, so it was used more often in the role of a bomber than a starfighter.

HOW TO FOLD: Y-WING

ENGINES

1 Start with a 1:2 rectangle, colored side down. Valley fold and unfold.

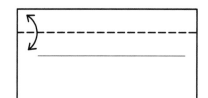

2 Valley fold and unfold.

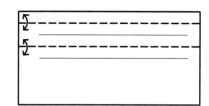

3 Valley fold and unfold.

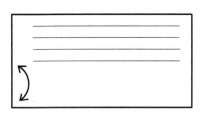

4 Repeat steps 2 and 3 on the bottom half.

5 Valley fold and unfold.

6 Valley fold and unfold.

7 Valley fold and unfold.

8 Valley fold and unfold.

9 Repeat steps 6 through 8 on the right side.

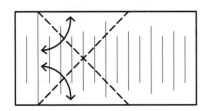

10 Valley fold and unfold. Repeat on the right.

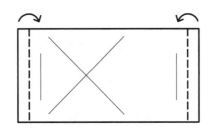

11 Valley fold. For steps 11 through 18, use existing creases.

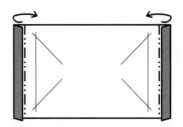

12 Mountain fold.

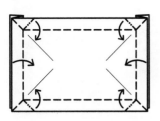

13 Make four rabbit ear folds.

14 Turn over.

15 Make four rabbit ear folds.

16 Turn over.

17 Make four rabbit ear folds.

18 Mountain fold.

19 Make two squash folds (note pocket A for step 20).

20 Tuck the flap formed in step 19 into the hidden pocket.

21 Flip the back flaps around to the front.

22 Reverse fold on the existing creases.

23 Valley fold and unfold. Repeat on the right.

24 Reverse fold. Repeat on the right.

25 Valley fold and unfold the top layer only. Repeat on the right.

26 Reverse fold the top layer only. Repeat on the right.

27 Insert the point into the pocket formed in step 26. Repeat on the right.

28 Finished Engines.

FUSELAGE
29 Start colored side down. Valley fold and unfold.

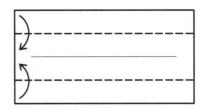

30 Valley fold.

31 Valley fold and unfold.

32 Reverse fold.

33 Valley fold the top layers.

34 Valley fold.

35 Mark fold.

36 Valley fold and unfold.

37 Sink fold on the crease formed in step 36.

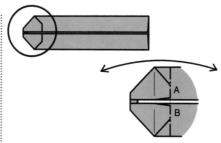

38 Mountain fold even with edges A and B. Unfold.

39 Valley fold.

40 Valley fold the flaps just past the edge to suggest two laser cannons.

41 Pleat fold on the creases formed in steps 33 and 40.

42 Valley fold.

43 Note line AB for step 45. Turn over.

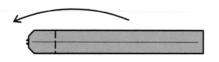

44 Valley fold on the crease formed in step 38.

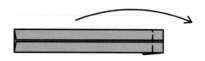

45 Valley fold on line AB shown in step 43.

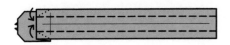

46 Squash fold.

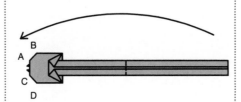

47 Mountain fold to the point where lines AB and CD would meet.

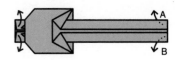

48 Unfold the top layers of the bottom flap, adding a pivot fold in corners A and B.

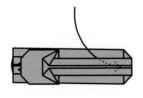
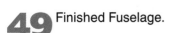

49 Finished Fuselage.

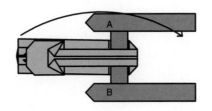

ASSEMBLY
50 Insert the Engines.

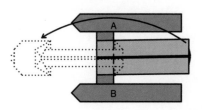

51 It will be easier to do steps 51 and 52 at the same time. Valley fold the bottom layer even with edge AB.

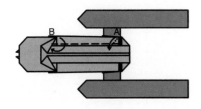

52 Squash fold A while inserting the lower flap into pocket B. Repeat on the bottom.

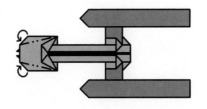

53 Mountain fold.

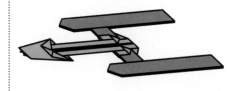

54 Finished Y-wing.

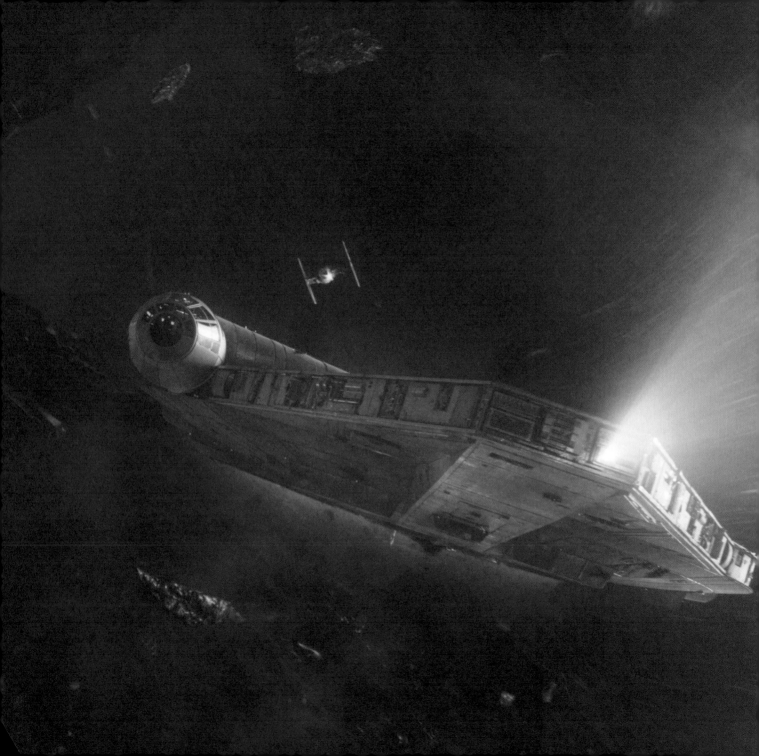

LANDO CALRISSIAN'S MILLENNIUM FALCON

The *Millennium Falcon* was Lando Calrissian's pride and joy. He went to great lengths to keep it clean and stylish both inside and out. Lando converted a YT dart into a comfortable escape pod and fitted it between the *Falcon*'s bow mandibles. The modification gave the *Falcon* a sleek, elegant look more in line with a luxury yacht than a freighter.

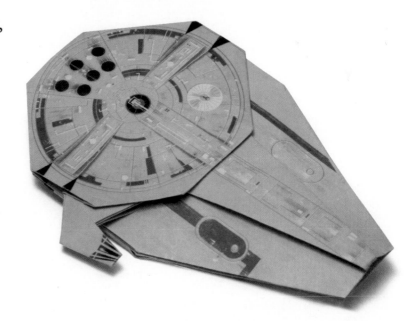

That is, until Han Solo got his hands on it.

HOW TO FOLD: LANDO CALRISSIAN'S MILLENNIUM FALCON

1 Start with a preliminary base, colored side down.

2 Valley fold and unfold.

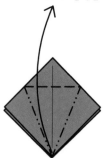

3 Squash fold. Repeat behind.

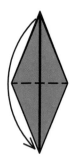

4 Valley fold. Repeat behind.

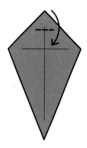

5 Mark fold.

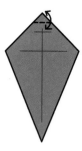

6 Valley fold and unfold.

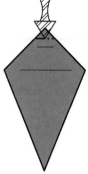

7 Sink fold.

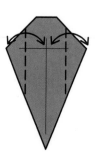

8 Valley fold and unfold. Repeat behind.

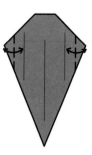

9 Valley fold and unfold. Repeat behind.

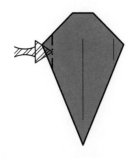

10 Sink fold.

11 Turn over.

12 Sink fold.

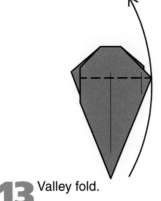

13 Valley fold.

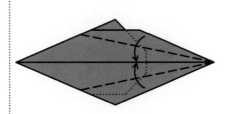

14 Valley fold.

15 Valley fold.

16 Unfold to step 14.

17 Valley fold even with the hidden edge.

18 Valley fold.

HOW TO FOLD: LANDO CALRISSIAN'S *MILLENNIUM FALCON* (CONT.)

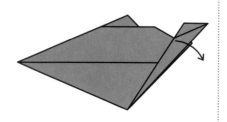

19 Unfold to step 17.

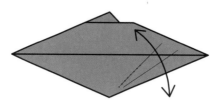

20 Repeat steps 17 through 19 on the upper half.

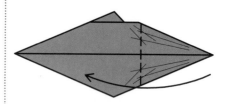

21 Valley fold. The crease goes through the intersection formed in steps 14 and 17.

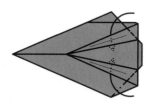

22 Reverse fold on the creases formed in steps 14 and 17.

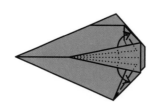

23 Reverse fold on the creases formed in steps 15 and 18.

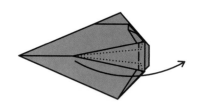

24 Valley fold as far as possible.

25 Mark fold.

26 Valley fold and unfold.

27 Reverse fold.

28 Valley fold.

29 Valley fold so the centerline of the flap (AB) is parallel to the centerline of the model (CD).

30 Valley fold even with corner A.

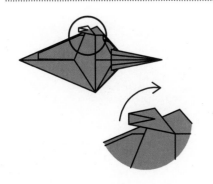

31 Unfold to step 29.

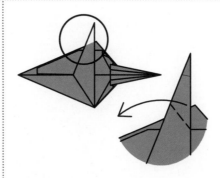

32 Outside reverse fold on the crease formed in step 29.

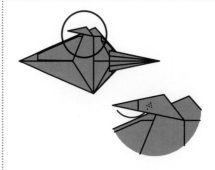

33 Reverse fold on the crease formed in step 30.

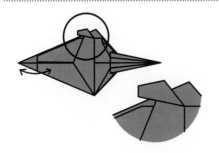

34 Valley fold and unfold.

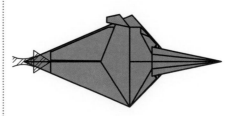

35 Sink fold.

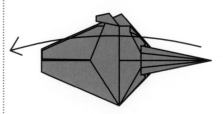

36 Fold the flap to the left.

HOW TO FOLD: LANDO CALRISSIAN'S *MILLENNIUM FALCON* (CONT.)

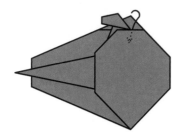

37 Using the existing crease, valley fold into the pocket formed in step 12.

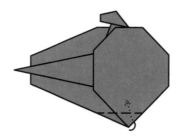

38 Using the existing crease, valley fold into the pocket formed in step 10.

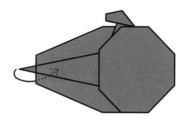

39 Mountain fold into the pocket formed in step 35.

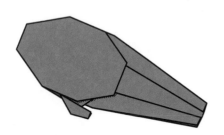

40 Finished Lando Calrissian's *Millennium Falcon.*

Which of these characters are blood relatives of the Skywalker family?

1. Anakin

2. Aunt Beru

3. Ben

4. Han

5. Leia

6. Luke

7. Padmé

8. Rey

9. Shmi

10. Uncle Owen

GENERAL GRIEVOUS' STARFIGHTER, THE *SOULLESS ONE*

General Grievous' personal starship, the *Soulless One*, is a Belbullab-22 starfighter. Even though the ship had two advanced laser cannons, deflector shields, and a hull coated with impervium, Grievous rarely engaged in ship-to-ship combat. Instead, his favorite feature of the craft was the long-range hyperdrive, as he preferred to escape situations rather than risk getting captured.

Obi-Wan Kenobi defeated Grievous on Utapau and stole the ship, which he used to escape clone troopers who turned on him following Order 66.

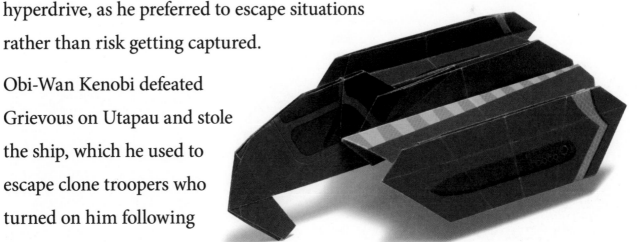

HOW TO FOLD: GENERAL GRIEVOUS' STARFIGHTER, THE *SOULLESS ONE*

1 Start colored side down. Fold into a preliminary base.

2 Valley fold and unfold.

3 Squash fold. Repeat behind.

4 Valley fold. Repeat behind.

5 Valley fold and unfold. Repeat on the right side.

6 Valley fold and unfold.

7 Valley fold and unfold.

8 Sink fold on the crease formed in step 6.

9 Sink fold on the crease formed in step 7. You may have to completely unfold the paper and refold steps 8 and 9 at the same time.

 10 Valley fold the top layer.

 11 Valley fold the top layer.

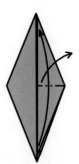 **12** Fold the point up while spreading the top layer to the right.

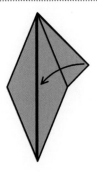 **13** Valley fold.

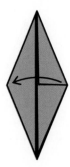 **14** Valley fold.

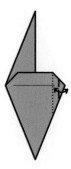 **15** Valley fold and unfold.

 16 Sink fold.

 17 Reverse fold.

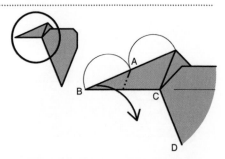 **18** Reverse fold so edge AB is parallel to edge CD. The paper should come out through the second pocket from the top.

19 Reverse fold into the bottom pocket. The crease starts about a third of the way.

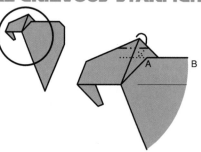

20 Reverse fold even with edge AB. Repeat behind.

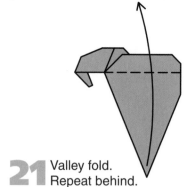

21 Valley fold. Repeat behind.

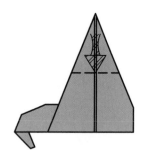

22 Valley fold and unfold. Repeat behind.

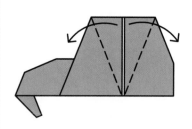

23 Sink fold. Repeat behind.

24 Valley fold. Repeat behind.

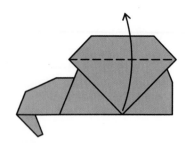

25 Valley fold. Repeat behind.

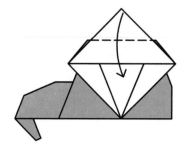

26 Valley fold even with the edge. Repeat behind.

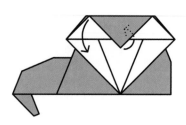

27 Valley fold the top flap down while tucking the small triangle into the pocket. Repeat behind.

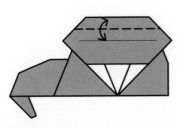

28 Valley fold. Repeat behind.

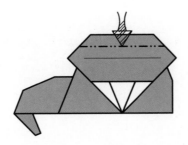

29 Valley fold. Repeat behind.

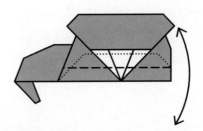

30 Valley fold and unfold. Repeat behind.

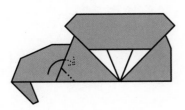

31 Reverse fold. Repeat behind.

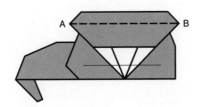

32 Swivel the engine 90 degrees on line AB. Repeat behind.

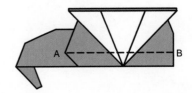

33 Swivel the engine 90 degrees on line AB. Repeat behind.

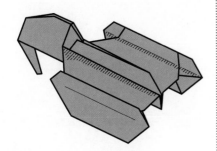

34 Finished General Grievous' starfighter, the *Soulless One*.

LANDO CALRISSIAN

Han Solo: "Lando's not a system, he's a man. Lando Calrissian. He's a card player, gambler, scoundrel. You'd like him."

Leia: "Do you trust him?"

Han Solo: "No, but he's got no love for the Empire."

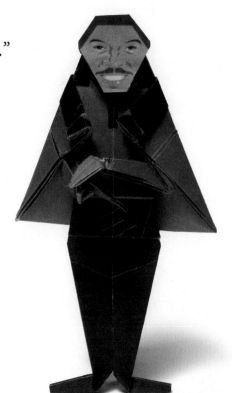

Lando Calrissian was a suave, smooth-talking con artist. He was once a smuggler, an owner of the *Millennium Falcon*, a Baron Administrator of Bespin's Cloud City, and a general in the Rebel Alliance. He may not have been the most trustworthy being in the galaxy, but he always did the right thing in the end.

HOW TO FOLD: LANDO CALRISSIAN

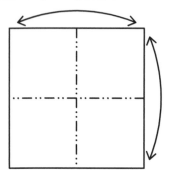

1 Start colored side down.
Mountain fold and unfold.

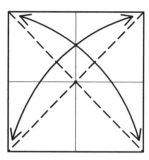

2 Valley fold and unfold.

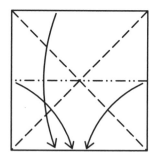

3 Collapse into a waterbomb.

4 Valley fold and unfold.

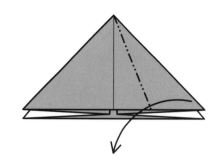

5 Squash fold.

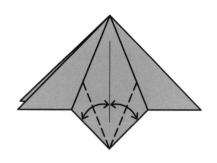

6 Valley fold and unfold.

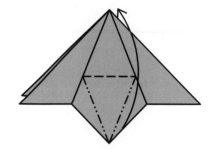

7 Petal fold.

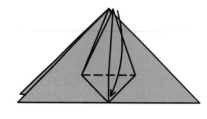

8 Valley fold.

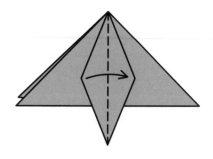

9 Valley fold.

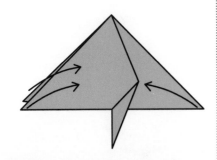

10 Repeat steps 4 through 9 on the other corners.

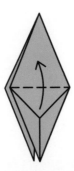

11 Valley fold. Repeat behind.

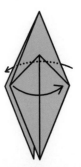

12 Valley fold two layers. Repeat behind.

13 Valley fold. Repeat behind.

14 Mark fold.

15 Valley fold.

16 Sink fold.

17 Sink the triangular area. Repeat behind.

18 Valley fold two layers. Repeat behind.

19 Sink the triangular area. Repeat behind.

20 Valley fold the top layer.

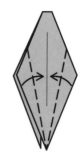

21 Valley fold.

22 Valley fold.

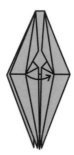

23 Valley fold.

24 Repeat steps 20 through 23 on the left.

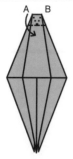

25 Valley fold edge AB while spreading the hidden paper open.

26 Turn over.

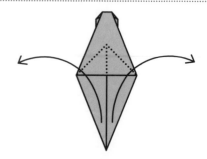

27 Reverse fold using the existing creases.

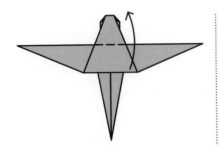

28 Valley fold.

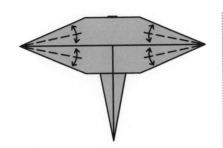

29 Valley fold and unfold. The creases will be used in step 41.

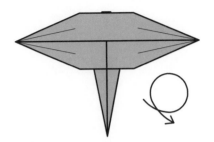

30 Turn over.

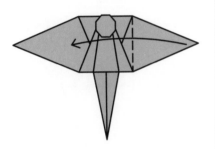

31 Valley fold.

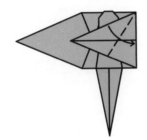

32 Valley fold.

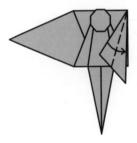

33 Valley fold.

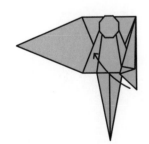

34 Unfold to step 32.

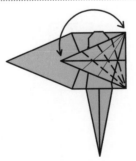

35 Repeat steps 32 through 34.

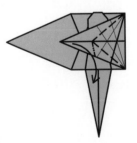

36 Rabbit ear fold on the existing crease.

HOW TO FOLD: LANDO CALRISSIAN (CONT.)

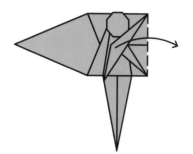

37 Valley fold.

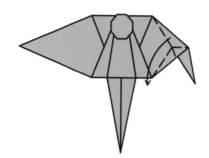

38 Rabbit ear fold on the existing crease.

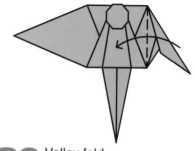

39 Valley fold.

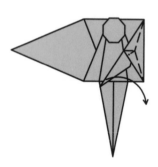

40 Rabbit ear fold on the existing crease.

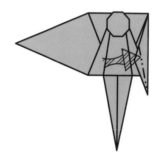

41 Sink fold on the crease formed in step 29.

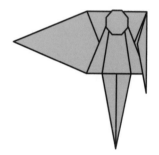

42 Repeat steps 31 through 41 on the left.

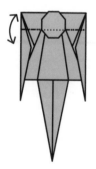

43 Mountain fold to the center crease and unfold.

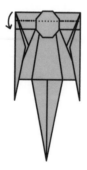

44 Mountain fold.

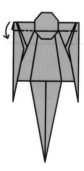

45 Mountain fold.

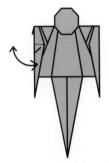

46 Valley fold and unfold.

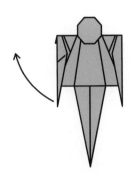

47 Outside reverse fold.

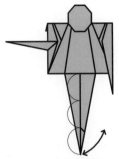

48 Valley fold and unfold. The crease starts a third of the way up.

49 Reverse fold.

50 Reverse fold about a third of the way.

51 Repeat steps 48 through 50 on the other foot.

52 Valley fold the tip to the corner.

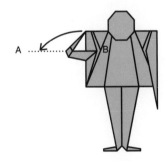

53 Valley fold even with edge AB.

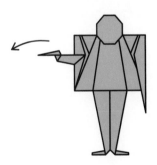

54 Unfold to step 52.

HOW TO FOLD: LANDO CALRISSIAN (CONT.)

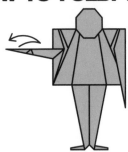

55 Pleat fold on the creases formed in steps 52 and 53 to form a blaster.

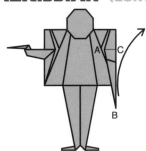

56 Valley fold so edge AB lands on C and is about 45 degrees from the centerline.

57 Valley fold.

58 Spread and squash the point to form a hand.

59 Narrow the face with two mountain folds.

60 Finished Lando Calrissian.

TEST YOUR STAR WARS IQ:
MATCHUP

Match the *Star Wars* character to the phrase used to refer to them.

1. "Chrome dome"

2. "Crazy old man"

3. "Laser brain"

4. "Little short circuit"

5. "Mindless philosopher"

6. "Stardust"

7. "Stunted slime"

8. "Traitor"

9. "Worm-ridden filth"

10. "Your Worshipfullness"

A. C-3PO

B. Finn

C. Leia Organa

D. Captain Phasma

E. Daultay Dofine

F. Jabba the Hutt

G. Ben Kenobi

H. R2-D2

I. Jyn Erso

J. Han Solo

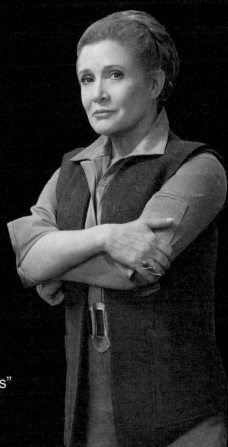

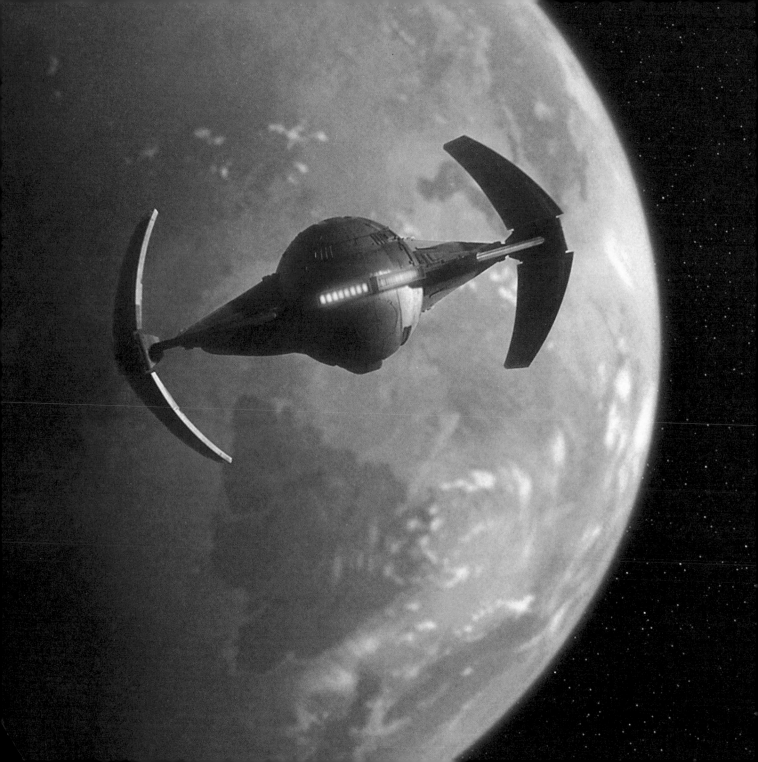

SITH INFILTRATOR

The *Scimitar*, Darth Maul's personal ship, was a modified star courier. The ship was upgraded with six laser cannons and a proton-torpedo launcher, while its most impressive feature was a cloaking device that rendered it invisible. The experimental ion engines were extremely powerful but generated a lot of excess heat. All in all, the vehicle was certainly a hunter-killer befitting a Dark Lord of the Sith.

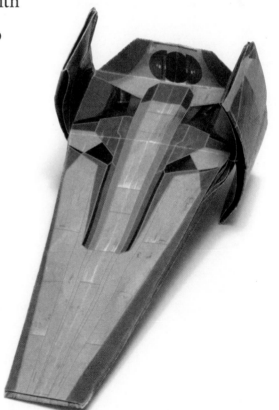

HOW TO FOLD: SITH INFILTRATOR

1 Start colored side down. Fold into a preliminary base.

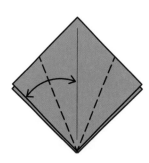

2 Valley fold and unfold.

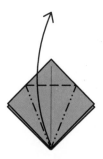

3 Squash fold. Repeat behind.

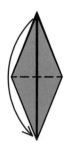

4 Valley fold. Repeat behind.

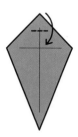

5 Mark fold.

6 Valley fold and unfold.

7 Sink fold.

8 Valley fold and unfold. Repeat behind.

9 Sink fold. Repeat behind.

10 Reverse fold the hidden points.

11 Inside reverse fold.

12 Valley fold and unfold. Repeat behind.

13 Sink fold on the bottom flap only.

14 Valley fold and unfold. Repeat behind.

15 Sink fold on the top flap only.

16 Tuck the point into the pocket formed in step 13.

17 Tuck the flaps into the pockets formed in step 15.

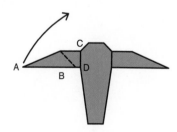

18 Valley fold so edge AB is parallel to edge CD.

HOW TO FOLD: SITH INFILTRATOR (CONT.)

19 Unfold to step 18.

20 Reverse fold.

21 Valley fold the top flap.

22 Valley fold and unfold.

23 Valley fold while spreading the paper to the sides.

24 Valley fold and unfold.

25 Reverse fold. Pockets will be formed at A and B.

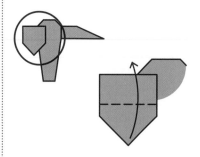

26 Valley fold along the hidden edge.

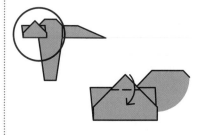

27 Valley fold. The crease should be just below the covered edge.

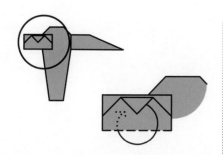

28 Valley fold into the pockets formed in step 25.

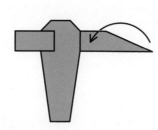

29 Repeat steps 18 through 28 on the right side.

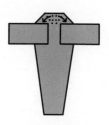

30 Reverse fold the two hidden triangles.

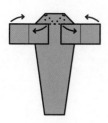

31 Pivot the wings 90 degrees.

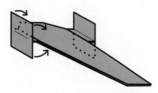

32 Curve the wings. Repeat on the right.

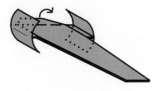

33 Pivot 90 degrees. Repeat beneath.

34 Finished Sith Infiltrator.

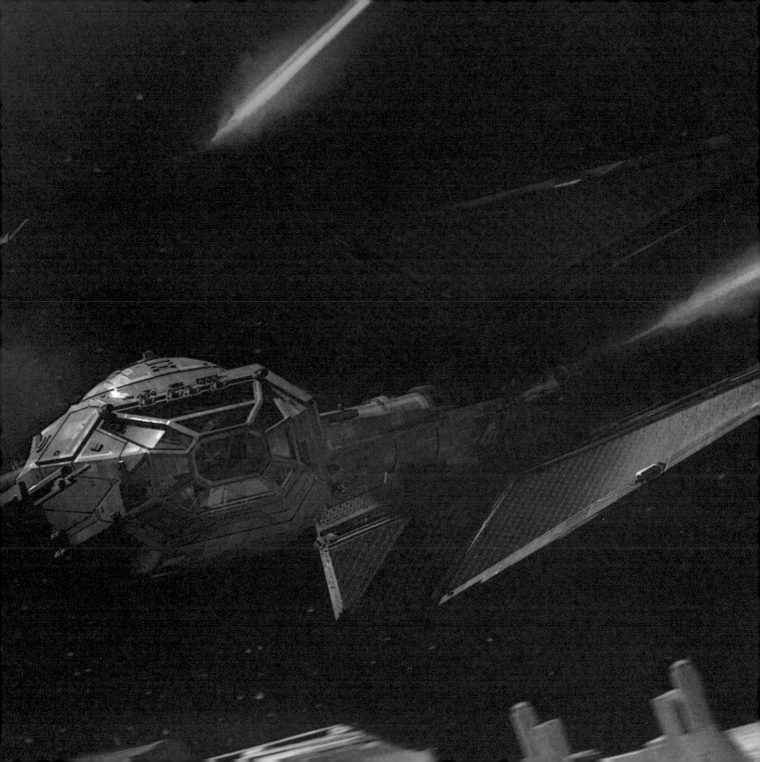

KYLO REN'S TIE SILENCER

The TIE silencer was one of the most advanced fighters in the TIE series. The angled wings (originally developed for the TIE Advanced x1) gave it outstanding maneuverability. The four laser cannons (first introduced on the TIE interceptor) gave it superior firepower. The ship also had missile launchers, shields, and advanced countermeasure/jamming systems, making it practically invisible to enemy ships.

Kylo Ren used one as his personal fighter. When Ren made an attack run on the Resistance star cruiser the *Raddus*, he was able to use the agility and firepower of his ship to single-handedly destroy the hangar bay.

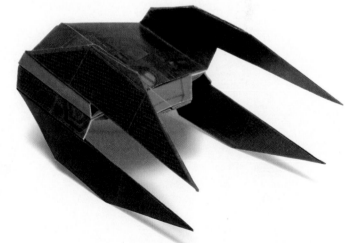

HOW TO FOLD: KYLO REN'S TIE SILENCER

1 Start colored side down. Fold into a preliminary base.

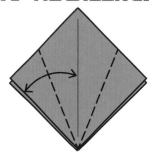

2 Valley fold and unfold.

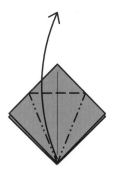

3 Squash fold. Repeat behind.

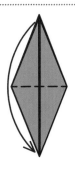

4 Valley fold. Repeat behind.

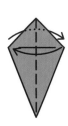

5 Valley fold. Repeat behind.

6 Valley fold and unfold. Repeat behind.

7 Valley fold and unfold. Repeat on the right side.

8 Unfold to step 1.

VALLEY FOLDS ARE IN RED.
MOUNTAIN FOLDS ARE IN BLUE.

9 Re-crease these lines as valley or mountain folds as indicated.

10 Collapse area ABC onto area BCD using the existing creases.

THE MODEL WILL NOT LIE FLAT.

11 Repeat step 10 on the other three corners.

THE MODEL WILL NOT LIE FLAT.

12 Using the existing creases, valley fold the edges inward.

13 Halfway through step 12.

14 Valley fold and unfold.

15 Sink fold.

16 Valley fold and unfold.

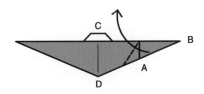

17 Valley fold so edge AB is parallel to centerline CD.

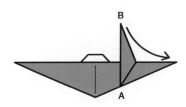

18 Unfold.

HOW TO FOLD: KYLO REN'S TIE SILENCER (CONT.)

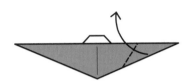

19 Outside reverse fold.

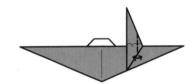

20 Valley fold about a third of the way. Unfold.

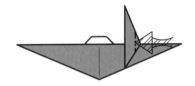

21 Sink fold.

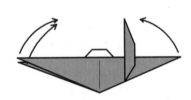

22 Repeat steps 17 through 21 on the left side and behind.

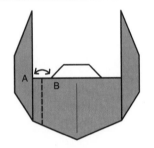

23 Valley fold A to B and unfold 90 degrees. Repeat on the right and behind.

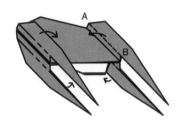

24 Angle the wings about 45 degrees inward along edges AB.

25 Finished Kylo Ren's TIE silencer.

TEST YOUR ★ STAR WARS IQ:
MATCHUP

Match each actor to the *Star Wars* character they portrayed.

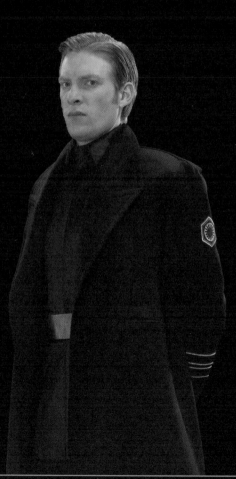

1. Anthony Daniels

2. Gwendoline Christie

3. Donnie Yen

4. Christopher Lee

5. Ray Park

6. Ben Mendelsohn

7. Ian McDiarmid

8. Domhnall Gleeson

9. Phoebe Waller-Bridge

10. Liam Neeson

11. Kelly Marie Tran

12. Thandie Newton

13. Denis Lawson

A. Chirrut Îmwe

B. Rose Tico

C. Emperor Palpatine

D. Wedge Antilles

E. Darth Maul

F. Qui-Gon Jinn

G. Count Dooku

H. Val

I. C-3PO

J. General Hux

K. Director Orson Krennic

L. Captain Phasma

M. L3-37

A-WING

The A-wing was one of the fastest starfighters in the galaxy, faster even than the famed TIE interceptor. While lightly shielded and armored, it had two powerful engines, missile launchers, and twin pivoting laser cannons that packed quite a punch for its size. The small, agile ship had a slender silhouette, making it difficult to hit.

The RZ-1 A-wing saw wide use during the final battles with the Empire. The RZ-2 version was still being used by the Resistance against the First Order.

HOW TO FOLD: A-WING

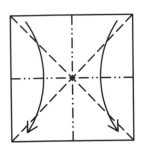

1 Start colored side down. Collapse into a waterbomb.

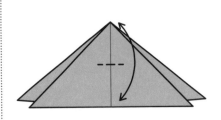

2 Mark fold.

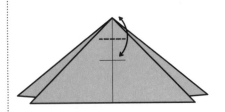

3 Mark fold.

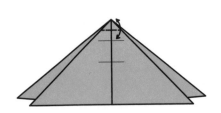

4 Valley fold and unfold.

5 Sink fold.

6 Valley fold.

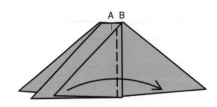

7 Valley fold halfway between centerline A and edge B.

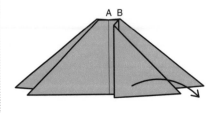

8 Unfold to step 6.

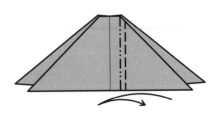

9 Pleat fold on the creases formed in steps 6 and 7.

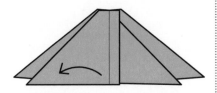

10 Repeat steps 6 through 9 on the left side.

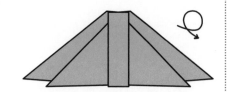

11 Turn the model over.

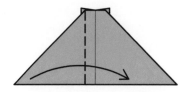

12 Valley fold.

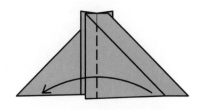

13 Valley fold even with the centerline.

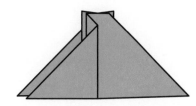

14 Unfold to step 12.

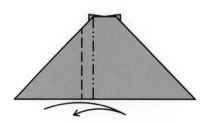

15 Pleat fold on the creases formed in steps 12 and 13.

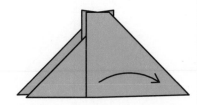

16 Repeat steps 12 through 15 on the right side.

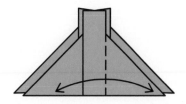

17 Valley fold and unfold.

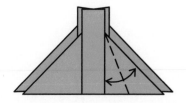

18 Valley fold and unfold.

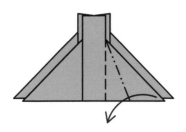

19 Squash fold.

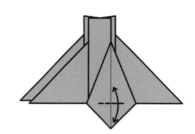

20 Mark fold.

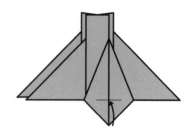

21 Valley fold.

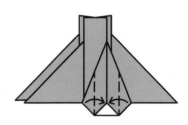

22 Valley fold.

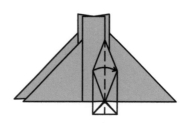

23 Valley fold.

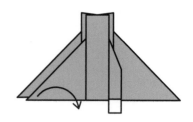

24 Repeat steps 17 through 23 on the left side.

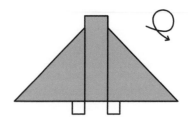

25 Turn over.

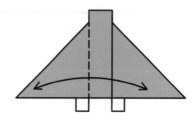

26 Valley fold and unfold.

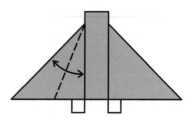

27 Valley fold and unfold.

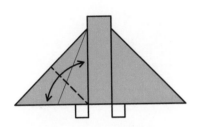

28 Valley fold and unfold.

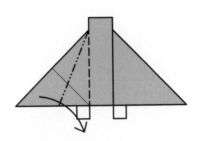

29 Squash fold.

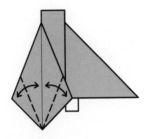

30 Valley fold and unfold.

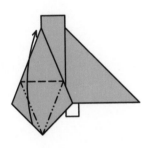

31 Petal fold.

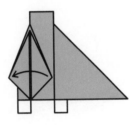

32 Valley fold.

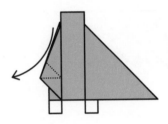

33 Reverse fold the inner flap.

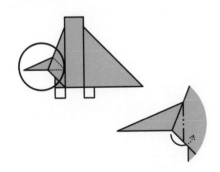

34 Mountain fold. Repeat behind.

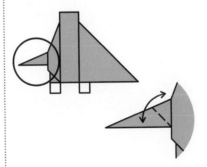

35 Valley fold and unfold.

36 Reverse fold.

37 Valley fold.

38 Valley fold.

39 Valley fold.

40 Repeat steps 26 through 39 on the right side.

41 Finished A-wing.

TEST YOUR STAR WARS IQ:
MATCHUP

Match each planet to the *Star Wars* movie it appeared in.

1. Crait **A.** *Solo: A Star Wars Story*

2. Exegol **B.** *Attack of the Clones*

3. Hoth **C.** *The Last Jedi*

4. Jakku **D.** *Rogue One: A Star Wars Story*

5. Kamino **E.** *The Rise of Skywalker*

6. Kashyyyk **F.** *The Empire Strikes Back*

7. Kessel **G.** *Revenge of the Sith*

8. Scarif **H.** *The Force Awakens*

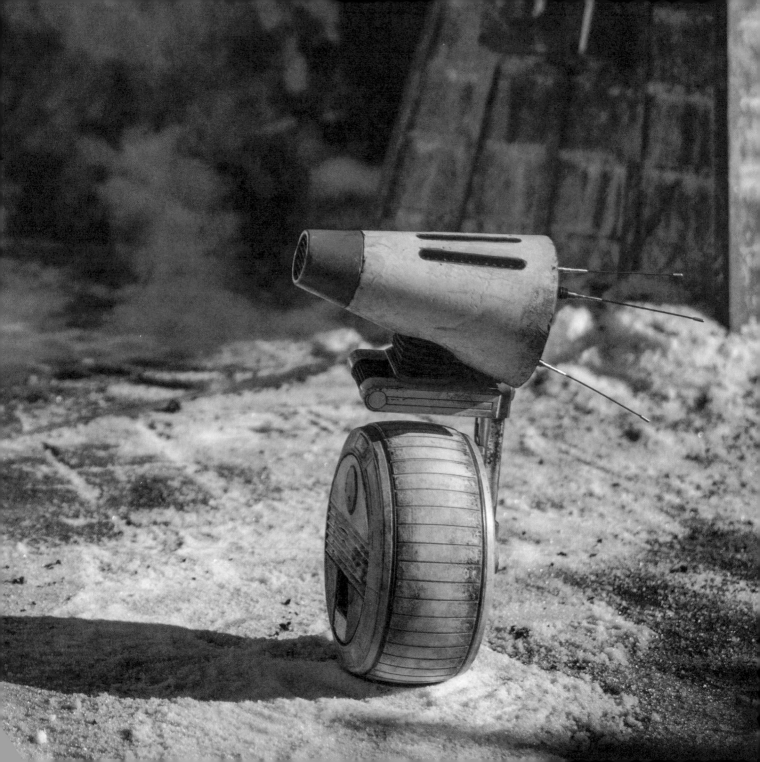

D-O

For more than ten years, D-O was left neglected and inactive aboard an assassin's ship. Rescued by Rey, D-O was immediately drawn to BB-8, who became a guide and guardian as D-O joined the Resistance and took his place among iconic droids like C-3PO and R2-D2. Custom-built, D-O had a thick rolling disk, a conical head, and a data port fitted with a storage drive that was separate from his brain, allowing him to carry data but not access it. He helped the Resistance by providing them with crucial information about the planet Exegol.

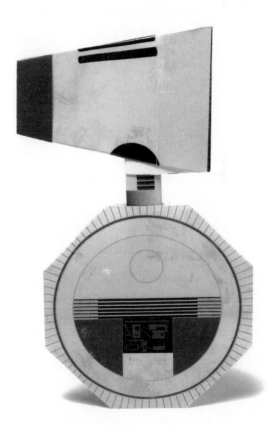

HOW TO FOLD: D-O

1 Valley fold and unfold.

2 Cut the paper into two 1 x 2 rectangles.

HEAD

3 Start with one rectangle, colored side down. Valley fold and unfold.

4 Valley fold and unfold.

5 Mark fold.

6 Mark fold.

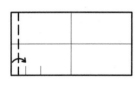

7 Valley fold.

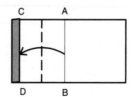

8 Valley fold so crease AB lands on edge CD.

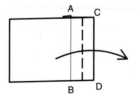

9 Valley fold so crease AB lands on edge CD.

10 Unfold to step 8.

11 Mountain fold.

12 Valley fold and unfold.

13 Squash fold.

14 Valley fold.

15 Valley fold.

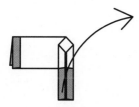

16 Unfold to step 11.

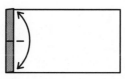

17 Mark fold.

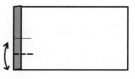

18 Mark fold.

HOW TO FOLD: D-O (CONT.)

19 Mark fold.

20 Mountain fold on the crease formed in step 9.

21 Mountain fold.

22 Reverse fold on the crease formed in step 13.

23 Mountain fold using the lower crease formed in step 19. Repeat behind.

24 Mountain fold on the crease formed in step 14. Repeat behind.

25 Mountain fold on the crease formed in step 15. Repeat behind.

26 Reverse fold using the upper crease formed in step 19.

27 Finished Head.

WHEEL

28 Start with second rectangle, colored side up. Valley fold and unfold.

29 Mark fold.

30 Mark fold.

31 Valley fold.

32 Mark fold.

33 Valley fold.

34 Valley fold even with edge AB.

35 Valley fold and unfold.

36 Valley fold.

HOW TO FOLD: D-O (CONT.)

37 Unfold the flap.

38 Insert the flap into the pocket formed in step 31.

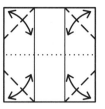

39 Valley fold the corners to the creases formed in step 30. Unfold.

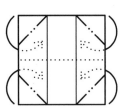

40 Reverse fold the corners.

41 Finished Wheel.

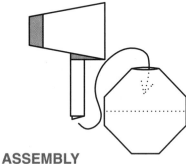

ASSEMBLY

42 Insert the Head into the Wheel. The Head should sit in the pocket formed in step 36.

43 Finished D-O.

TEST YOUR STAR WARS IQ:
TRIVIA

1. What was the number of the Death Star docking bay the *Millennium Falcon* landed in?
A. 327
B. 1138
C. 2187

2. What was the number of the cell Princess Leia was held in on the Death Star?
A. 327
B. 1138
C. 2187

3. What was the designation of the battle droid Jar Jar Binks knocked over during the Battle of Naboo?
A. 327
B. 1138
C. 2187

4. What was the designation number of Queen Amidala's Royal Starship?
A. 327
B. 1138
C. 2187

5. Which cell block did Luke Skywalker say Chewbacca was being transferred from?
A. 327
B. 1138
C. 2187

6. What was the number of the platform the *Millennium Falcon* landed on in Cloud City?
A. 327
B. 1138
C. 2187

7. What was Finn's stormtrooper designation number?
A. 327
B. 1138
C. 2187

FINN

The First Order conscripted Finn as a very young child and trained him to be a stormtrooper. On his first mission under the command of Captain Phasma, he and his squad were tasked with finding the secret map to Luke Skywalker. During the fight, FN-2187's closest friend was shot and died in his arms. After the village surrendered, Kylo Ren ordered the execution of all its inhabitants. FN-2187 couldn't bring himself to fire on unarmed prisoners and started questioning his place in the First Order.

Once back onboard the First Order Star Destroyer, the *Finalizer*, FN-2187 decided to defect. Since he couldn't pilot a ship himself, he helped captured Resistance pilot Poe Dameron escape. Unfortunately, they were shot down in the attempt and crash-landed on Jakku. The only trace of Poe in the wreckage was his jacket. Assuming his new friend was dead, Finn swapped his stormtrooper armor for it and made his way off Jakku. Later Finn and Poe were reunited at the Resistance base.

HOW TO FOLD: FINN

LOWER BODY

1 Start with an equilateral triangle colored side up. Valley fold.

2 Valley fold and unfold.

3 Squash fold.

4 Valley fold and unfold.

5 Petal fold.

6 Turn over.

7 Squash fold.

8 Valley fold and unfold.

9 Petal fold.

10 Flip the top layer of paper over to the back side.

11 Valley fold and unfold.

12 Sink fold.

13 Valley fold and unfold.

14 Sink fold.

15 Valley fold and unfold. Repeat on the left.

16 Valley fold and unfold. Repeat on the left.

17 Pleat fold on the creases formed in steps 15 and 16. Repeat on the left.

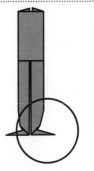

18 Reverse fold about a third of the foot. Repeat on the left.

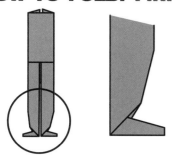

19 Finished lower half.

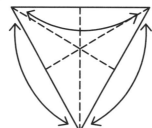

UPPER BODY

20 Start with an equilateral triangle colored side down. Valley fold and unfold.

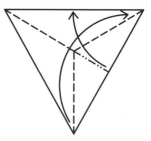

21 Rabbit ear fold.

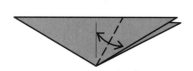

22 Valley fold and unfold.

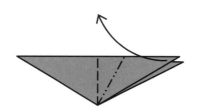

23 Squash fold.

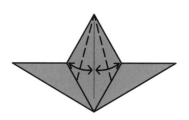

24 Valley fold and unfold.

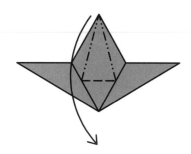

25 Petal fold.

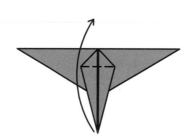

26 Valley fold.

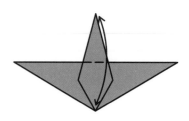

27 Valley fold in half and unfold.

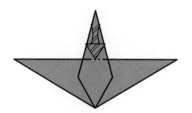

28 Sink fold.

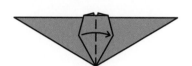

29 Valley fold.

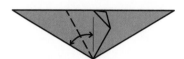

30 Repeat steps 22 through 26 on this flap.

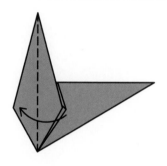

31 Valley fold the top flap.

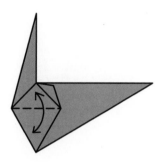

32 Valley fold and unfold.

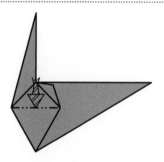

33 Sink the top layer.

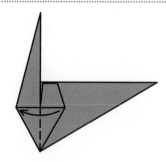

34 Valley fold the top layer.

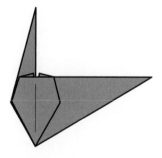

35 Repeat steps 29 through 34 on this flap.

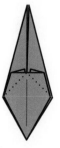

36 Repeat steps 32 and 33 on the flap in the back.

HOW TO FOLD: FINN (CONT.)

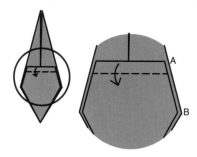

37 Valley fold about a fourth of the distance between A and B.

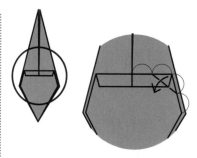

38 Valley fold. The crease starts about halfway between the edges. Repeat on the left.

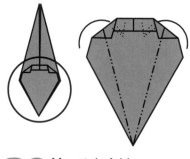

39 Mountain fold.

40 Reverse fold the existing creases.

41 Pivot at point A so edge BC lies perpendicular to edge AB. Repeat on the right.

42 Mountain fold the corners inward as far as they'll go. Repeat behind.

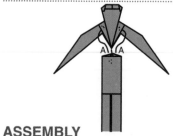

ASSEMBLY

43 Insert the Upper Body into the pocket of the Lower Body, while inserting tabs A into the top pockets of the Upper Body and keeping them above the arms.

44 Valley fold the arms in half to suit your pose.

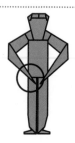
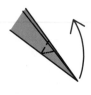

45 Squash fold about a fourth of the arm to form hands.

46 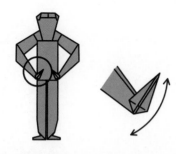 Valley fold and unfold.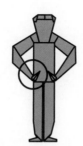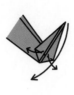

47 Valley fold while spreading the loose paper to the sides.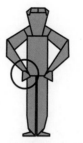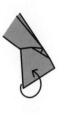

48 Curl the hands.

49 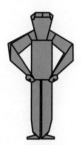 Finished Finn.

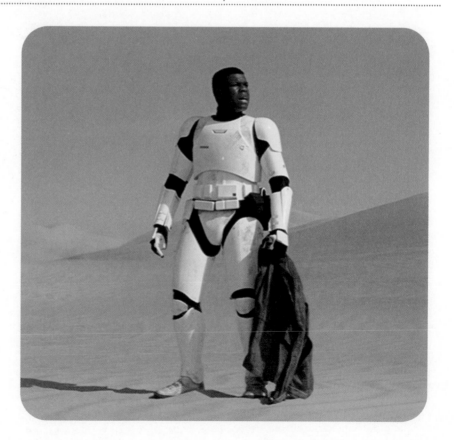

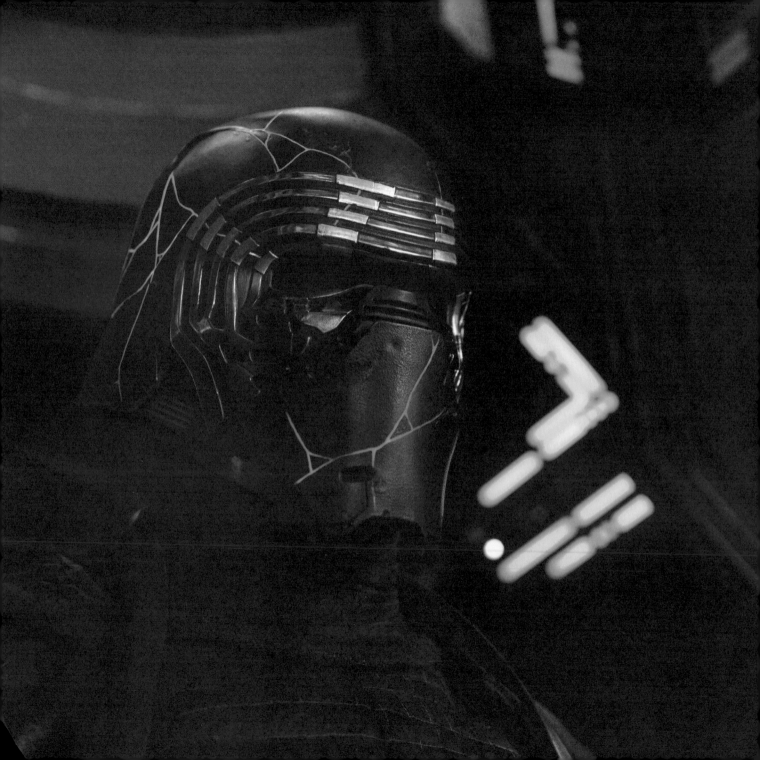

KYLO REN'S MASK

S on of Han Solo and Leia Organa, Kylo Ren (born Ben Solo) was a leader in the First Order and master of the Knights of Ren. He inherited his sensitivity to the Force from his Skywalker bloodline, and first trained as a Jedi Knight. But like his grandfather Darth Vader, he was seduced by the dark side, eventually becoming a student of Supreme Leader Snoke. To prove his loyalty to the dark side, he killed Han Solo and attempted to destroy General Leia's flagship, but he was unable to attack her. He also experienced a complicated pull to the light when he discovered a connection with Rey, who was also sensitive to the Force. When Supreme Leader Snoke gave him the order to kill Rey, Kylo killed Snoke instead, and assumed the title of Supreme Leader of the First Order.

HOW TO FOLD: KYLO REN'S MASK

1 Start colored side up. Mark fold.

2 Valley fold.

3 Valley fold and unfold.

4 Valley fold and unfold.

5 Valley fold and unfold.

6 Mountain fold and unfold.

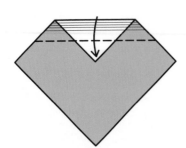

7 Valley fold on the crease formed in step 3.

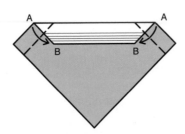

8 Valley fold points A to points B.

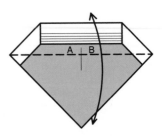

9 Mark fold from point A to point B.

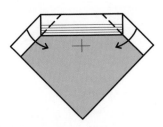

10 Valley fold.

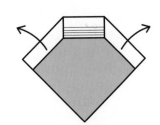

11 Unfold to step 8.

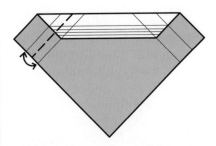

12 Mountain fold and unfold.

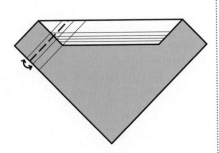

13 Mountain fold and unfold.

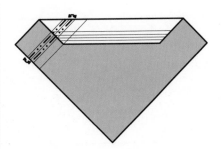

14 Valley fold and unfold.

15 Valley fold on the crease formed in step 8.

16 Valley fold on the crease formed in step 10.

17 Repeat steps 12 through 16 on the right side.

18 Valley fold corner A to the intersection formed in step 9.

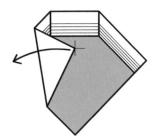

19 Unfold.

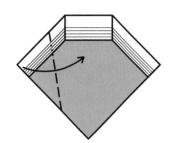

20 Reverse fold on the crease formed in step 18.

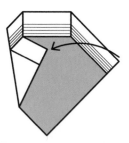

21 Repeat steps 18 through 20 on the right.

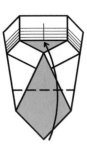

22 Valley fold.

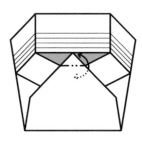

23 Mountain fold and unfold.

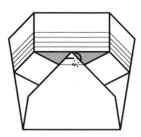

24 Mountain fold.

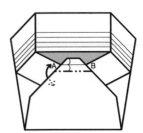

25 Mountain fold. The crease should be the same distance as the gap from the edge to crease AB. Unfold.

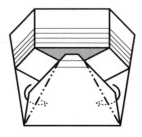

26 Mountain fold.

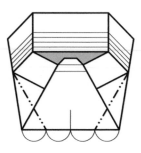

27 Mountain fold.

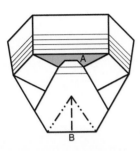

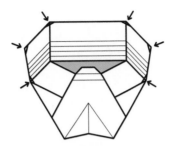

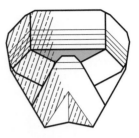

28 Shape the chin with three creases. The junction starts halfway between A and B.

29 Add small mountain folds to round out the helmet.

30 Finished Kylo Ren's mask.

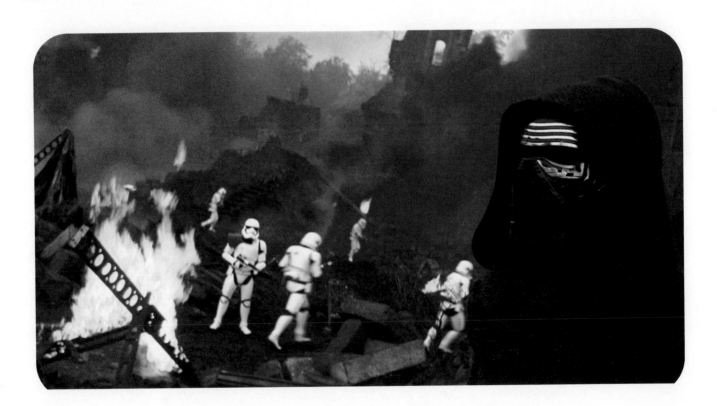

REY'S JAKKU SPEEDER

Rey was left behind on Jakku as a very young girl. Hoping someday someone would return for her, she survived by scavenging the wreckage of downed starships for parts she could trade for food and water. This hard life taught her many of the skills she would need once a chance meeting with BB-8 swept her up into galactic events. She became the last of the original Jedi and the first of the new generation.

Rey designed and built her speeder from parts she found in the Graveyard of Ships on Jakku. She used the engines, repulsor lifts, and afterburners from military gunships; racing swoop bikes; cargo haulers; and even X-wings to make the perfect speeder for a scavenger. It could haul heavy loads, and it moved like lightning when unladen.

HOW TO FOLD: REY'S JAKKU SPEEDER

1 Start colored side down. Valley fold and unfold.

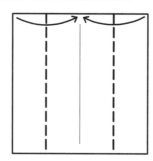

2 Valley fold.

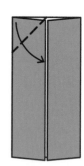

3 Valley fold.

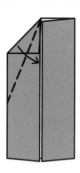

4 Valley fold.

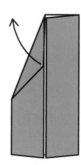

5 Unfold to step 3.

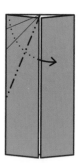

6 Reverse fold.

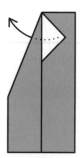

7 Reverse fold on the existing crease.

8 Repeat steps 3 through 7 on the right side.

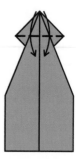

9 Valley fold the two flaps.

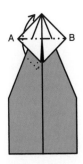

10 Mountain fold the flap in the back along line AB. Unfold.

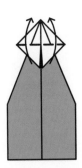

11 Unfold to step 9.

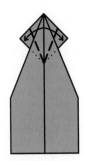

12 Valley fold.

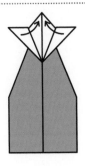

13 Unfold.

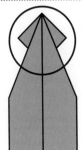
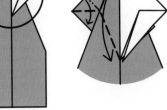
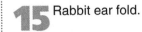

14 Rabbit ear fold.

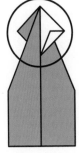

15 Rabbit ear fold.

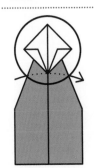
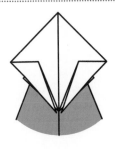

16 Mountain fold.

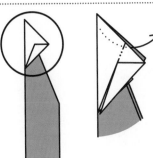

17 Reverse fold.

18 Reverse fold. Repeat behind.

HOW TO FOLD: REY'S JAKKU SPEEDER (CONT.)

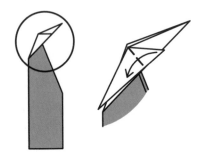 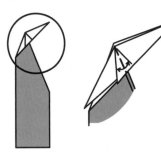 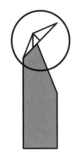

19 Valley fold. Repeat behind.

20 Valley fold and unfold. Repeat behind.

21 Valley fold and unfold. Repeat behind.

22 Rabbit ear fold. Repeat behind.

23 Mark fold onto edge AB and unfold.

24 Valley fold and unfold.

25 Reverse fold along edge AB.

26 Reverse fold on the crease formed in step 24.

27 Valley fold and unfold.

28 Reverse fold.

29 Rotate the model.

30 Valley fold.

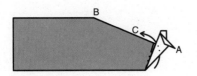

31 Mountain fold so tip A rests on edge BC.

32 Unfold to step 30.

33 Pleat fold on the creases formed in steps 30 and 31.

34 Uncover the hidden triangle. Repeat behind.

35 Valley fold.

36 Valley fold so edge AB is parallel to edge CB, and the hands (D) are in the corner. See step 37.

37 Unfold to step 35.

38 Pleat fold on the creases formed in steps 35 and 36.

39 Mountain fold the tip to edge AB. Repeat behind.

40 Mountain fold parallel to edge AB. Repeat behind.

41 Mountain fold. The crease ends halfway along edge AB. Repeat behind.

42 Valley fold and unfold. Repeat behind.

43 Reverse fold on the crease formed in step 42. Repeat behind.

44 Valley fold corners A and B similar to step 42.

45 Reverse fold the top corner on the crease formed in step 44.

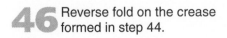

46 Reverse fold on the crease formed in step 44.

47 Valley fold into the pocket formed in step 45.

48 Finished Rey's Jakku speeder.

POE DAMERON'S T-70 X-WING

P oe Dameron was the best fighter pilot in the Resistance. Poe was born on Yavin 4 two years after the first Death Star was destroyed, and he idolized the pilots of the Rebel Alliance. As soon as he was old enough, he joined the New Republic's Defense Fleet and earned his reputation as an ace fighter pilot. He later joined the Resistance and was named commander of the starfighter corps.

When his beloved X-wing the *Black One* was destroyed in the First Order's attack on the *Raddus*, Poe started piloting the Incom T-70 X-wing fighter, the Resistance's signature combat ship in their fight against the First Order. Poe piloted this ship as he led the Resistance to victory in the Battle of Exegol, the decisive battle in the war between the First Order and the Resistance.

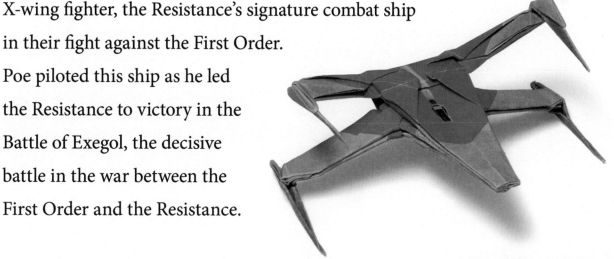

HOW TO FOLD: POE DAMERON'S T-70 X-WING

1 Start colored side down. Valley fold and unfold.

2 Mountain fold and unfold.

3 Valley fold and unfold.

4 Valley fold and unfold.

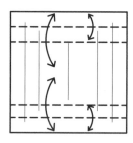

5 Repeat steps 3 and 4 on the top and bottom.

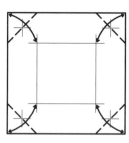

6 Valley fold and unfold.

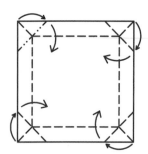

7 Collapse on the existing creases while making four simultaneous rabbit ear folds.

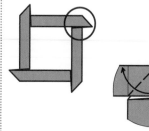

8 Squash fold on the existing creases.

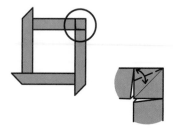

9 Valley fold and unfold.

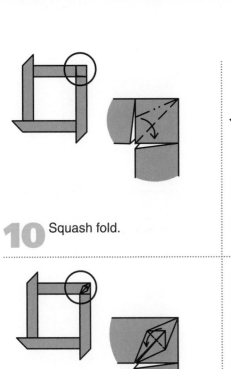

10 Squash fold.

11 Valley fold and unfold.

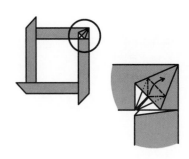

12 Petal fold.

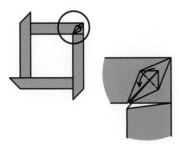

13 Valley fold.

14 Sink fold.

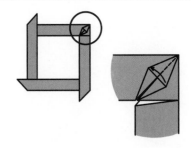

15 Valley fold.

16 Repeat steps 9 through 15 on the other corner.

17 Reverse fold the two hidden corners.

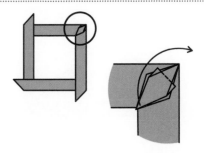

18 Valley fold.

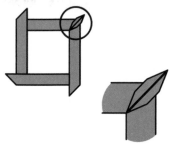

19 Repeat steps 8 through 18 on the other three corners.

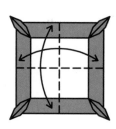

20 Valley fold and unfold.

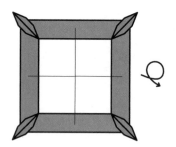

21 Turn over.

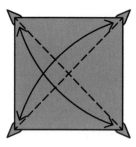

22 Valley fold and unfold.

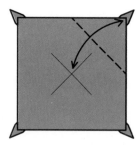

23 Valley fold and unfold. Repeat on the other three corners.

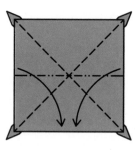

24 Collapse into a waterbomb base.

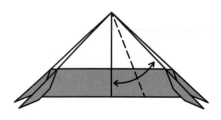

25 Valley fold and unfold.

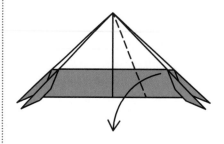

26 Squash fold.

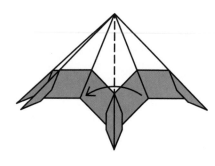

27 Valley fold.

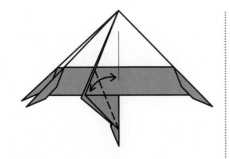

28 Valley fold and unfold.

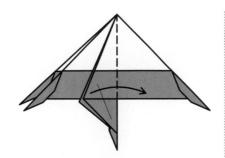

29 Unfold to step 27.

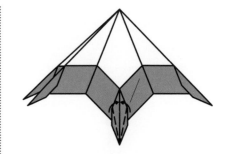

30 Valley fold.

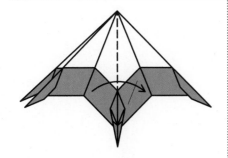

31 Valley fold.

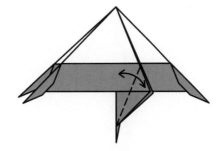

32 Valley fold and unfold.

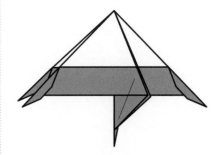

33 Unfold to step 31.

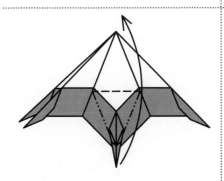

34 Petal fold.

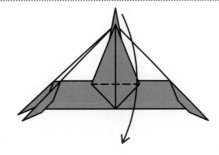

35 Valley fold.

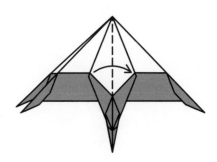

36 Valley fold.

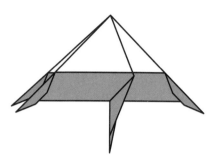

37 Repeat steps 25 through 36 on the other three corners.

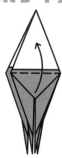

38 Valley fold.

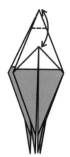

39 Mark fold.

40 Valley fold and unfold. Make sure the crease is sharp.

41 Sink fold.

42 Valley fold.

43 Sink fold the triangle. Repeat behind.

44 Fold two layers to the left. Repeat behind.

45 Reverse fold the upper flap.

46 Squash fold so corner A lands on centerline BC.

47 Repeat step 46 on the back side of the same flap.

48 Mountain fold the top layer.

49 Mountain fold the second layer.

50 Repeat steps 45 through 49 on the left side.

51 Turn over.

52 Reverse fold.

53 Reverse fold.

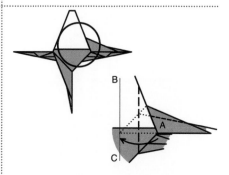

54 Squash fold so corner A lands on centerline BC, similar to step 46.

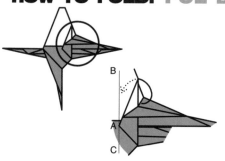

55 Repeat step 54 on the back side of the same flap.

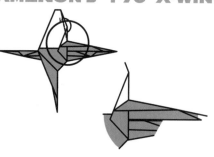

56 Mountain fold the top layer.

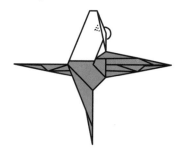

57 Mountain fold the second layer.

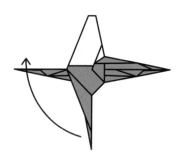

58 Repeat steps 52 through 57 on the left.

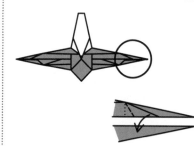

59 Reverse fold the small triangle. Repeat on the left.

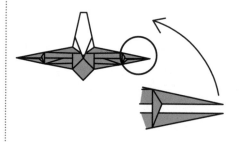

60 Pivot the large triangle. Repeat on the left.

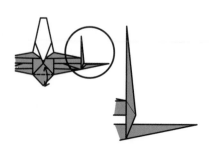

61 Valley fold and unfold.

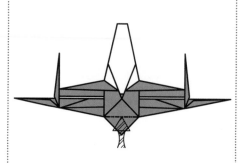

62 Sink fold.

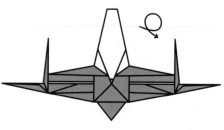

63 Turn over.

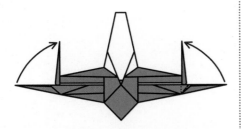

64 Outside reverse fold even with the lower wing. Repeat on the left.

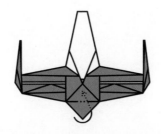

65 Mountain fold into the pocket formed in step 62. This will lock the model closed.

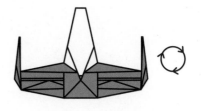

66 Rotate the model.

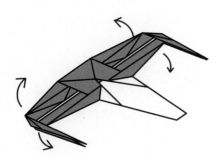

67 Separate the wings by about 45 degrees.

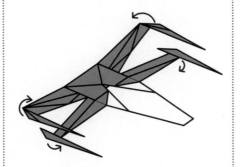

68 Valley fold the cannons 90 degrees.

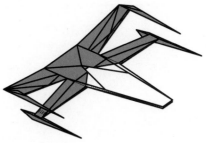

69 Finished Poe Dameron's T-70 X-wing.

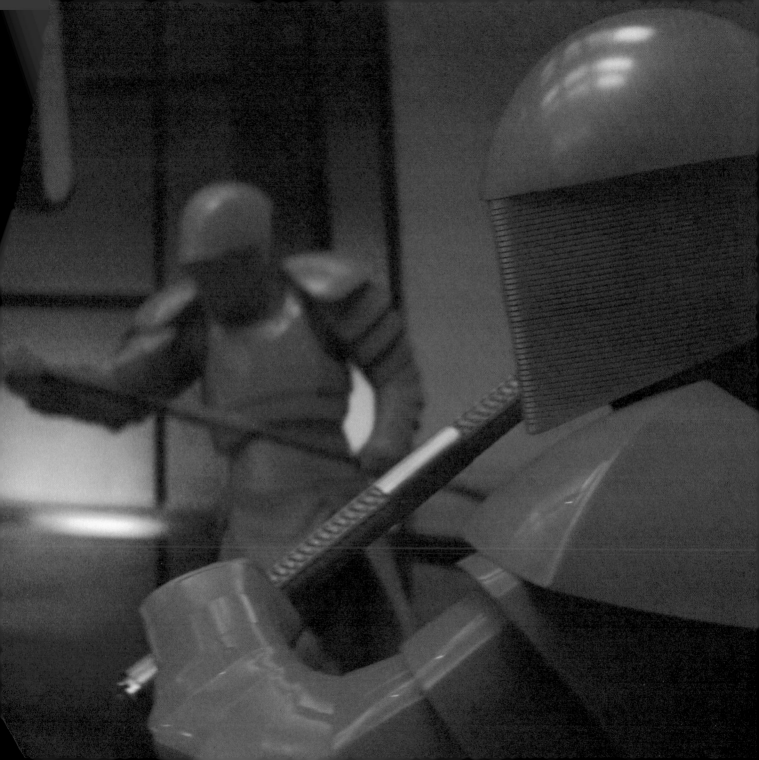

PRAETORIAN GUARD

The elite Praetorian Guards were Supreme Leader Snoke's personal bodyguards. The eight-member squad was highly trained in many forms of melee combat. Their armor and weapons were designed to deal with threats from lightsabers and other direct assaults. The First Order liked to use imagery from the days of the Empire, so the red armor and robes were deliberately similar to the robes worn by the Emperor's Royal Guard.

In spite of their training and attentiveness, the entire squad was as surprised as Snoke was by Kylo Ren's betrayal. They were defeated by Kylo and Rey in an attempt to avenge Snoke's death.

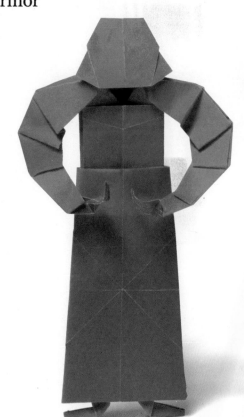

HOW TO FOLD: PRAETORIAN GUARD

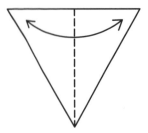

LOWER BODY

1 Start with an equilateral triangle, colored side down. Valley fold and unfold.

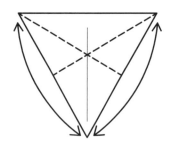

2 Valley fold and unfold.

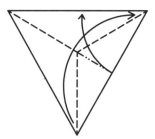

3 Rabbit ear fold. Valley fold and unfold.

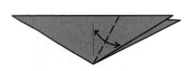

4 Valley fold and unfold.

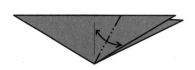

5 Squash fold.

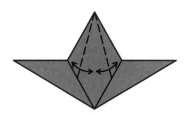

6 Valley fold and unfold.

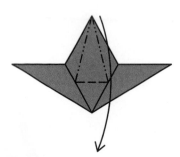

7 Petal fold.

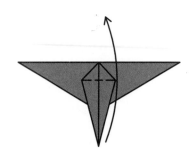

8 Valley fold.

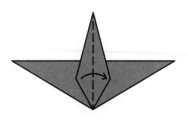

9 Valley fold.

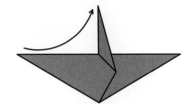

10 Repeat steps 4 through 9 on the left side.

11 Fold two layers to the left.

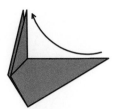

12 Repeat steps 4 through 9 on the right side.

13 Valley fold and unfold. Repeat behind.

14 Sink fold. Repeat behind.

15 Fold two flaps to the right.

16 Valley fold and unfold.

17 Sink fold.

18 Fold one flap to the left.

HOW TO FOLD: PRAETORIAN GUARD (CONT.)

19 Reverse fold the hidden triangles.

20 Valley fold the top flap.

21 Reverse fold.

22 Valley fold and unfold.

23 Sink fold.

24 Turn over.

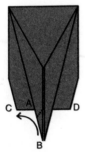

25 Reverse fold so edge AB is parallel to edge CD. Repeat on the right.

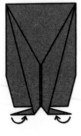

26 Reverse fold about a fourth of the length to make feet.

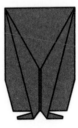

27 Finished Lower Body.

UPPER BODY
28 Start with an equilateral triangle, colored side down. Repeat steps 1 through 18.

29 Valley fold.

30 Valley fold two flaps to the left.

31 Valley fold.

32 Valley fold and unfold.

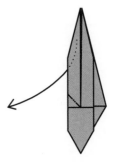

33 Reverse fold.

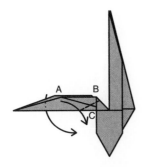

34 Outside reverse fold so edge AB lands on corner C at about a 45-degree angle.

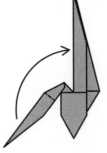

35 There are no guide folds for steps 36 through 48. Valley fold.

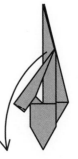

36 Valley fold.

HOW TO FOLD: PRAETORIAN GUARD (CONT.)

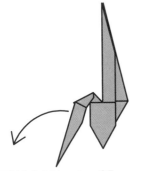

37 Unfold to step 35.

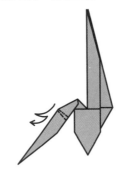

38 Pleat fold on the creases formed in steps 35 and 36.

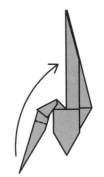

39 Valley fold.

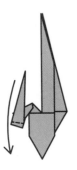

40 Valley fold.

41 Unfold to step 39.

42 Pleat fold on the creases formed in steps 39 and 40.

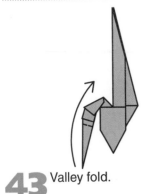

43 Valley fold.

44 Valley fold.

45 Unfold and pleat on the creases formed in steps 43 and 44.

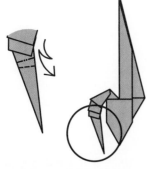

46 Pleat fold as in steps 39 through 42.

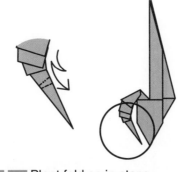

47 Pleat fold as in steps 39 through 42.

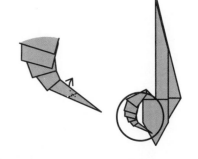

48 Reverse fold.

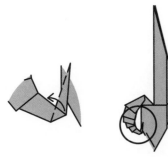

49 Valley fold.

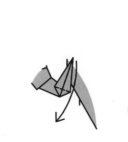

50 Valley fold.

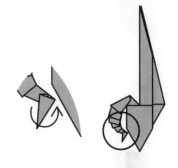

51 Curl the triangle to form a hand.

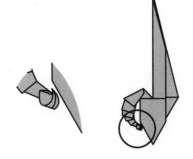

52 Repeat steps 32 through 51 on the right.

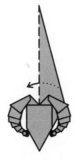

53 Unfold one flap in the back.

54 Repeat step 29 on the back.

HOW TO FOLD: PRAETORIAN GUARD (CONT.)

 55 Valley fold corner A to corner B.

 56 Valley fold halfway between edge AB and hidden edge CD.

 57 Reverse fold. For the Style I Helmet, continue to step 58; for the Style II Helmet, skip to step 66.

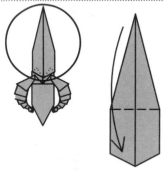

STYLE I HELMET
58 Valley fold.

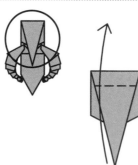 **59** Valley fold about a third of the way from A to B.

 60 Mountain fold.

 61 Mountain fold.

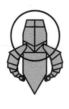 **62** Turn over.

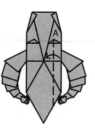 **63** Squash fold at A. Repeat on the left.

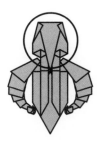

64 Valley fold to narrow the helmet.

65 Finished Style I Helmet. Skip ahead to step 75.

 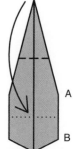

A

B

STYLE II HELMET

66 Valley fold the point halfway between A and B. Unfold.

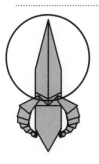

67 Sink fold.

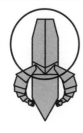

68 Valley fold.

69 Valley fold.

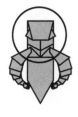

70 Mountain fold.

71 Turn over.

A

72 Squash fold at A. Repeat on the left.

HOW TO FOLD: PRAETORIAN GUARD (CONT.)

73 Valley fold to narrow the helmet.

74 Finished Style II Helmet.

ASSEMBLY
75 Valley fold on Upper Body.

76 Insert the Upper Body into the pocket in the Lower Body.

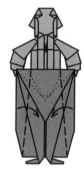

77 Valley fold.

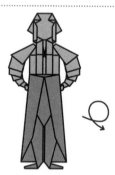

78 Turn over.

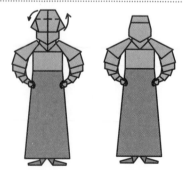

79 Pivot the flap about 45 degrees on the Style II Helmet.

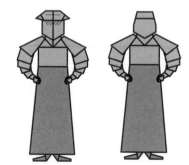

80 Finished Praetorian Guard.

TEST YOUR STAR WARS IQ:
MATCHUP

Which *Star Wars* movie's first sentence is...

1. "At Last."

2. "Captain!"

3. "Come on, come on!"

4. "Command station, this is ST-321."

5. "Did you hear that?"

6. "Echo three to echo seven."

7. "Lock onto them, Artoo!"

8. "Momma!"

9. "Senator, we're making our final approach into Coruscant."

10. "This will begin to make things right."

11. "We're not clear yet!"

A. *The Force Awakens*

B. *Attack of the Clones*

C. *The Last Jedi*

D. *Revenge of the Sith*

E. *The Phantom Menace*

F. *Rogue One: A Star Wars Story*

G. *Return of the Jedi*

H. *A New Hope*

I. *The Empire Strikes Back*

J. *Solo: A Star Wars Story*

K. *The Rise of Skywalker*

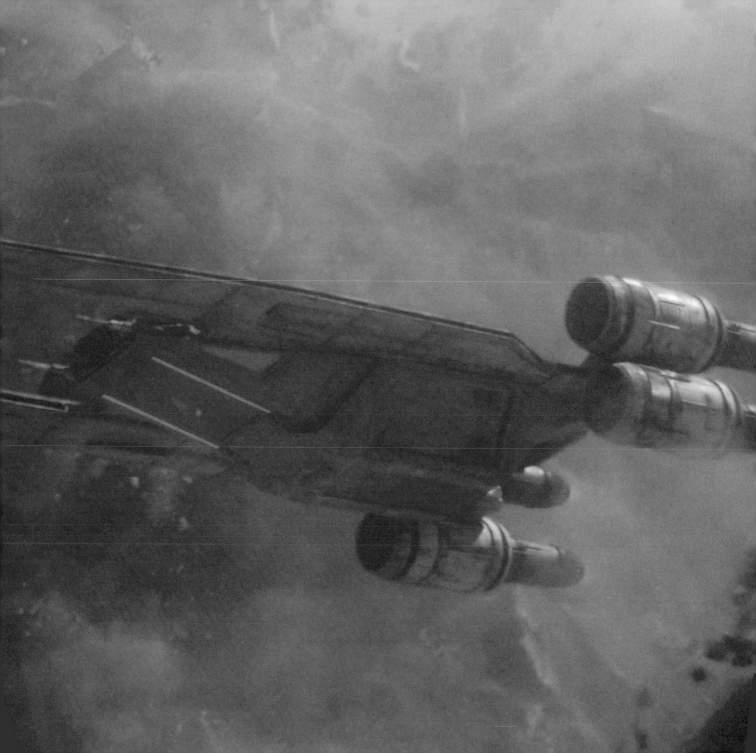

U-WING

The U-wing was a troop transport/gunship used by the Rebel Alliance. Its main role was transporting small squads of ground troops into battle and then providing air support from side-mounted door cannons. The ship was armed with two forward-facing laser cannons for defense, while its most prominent feature was its two long S-foils. These could be extended for interstellar flight to help dissipate the heat generated by its four large engines and to increase its deflector-shield coverage. But the S-foils weren't well suited for atmospheric flight. Since they tended to create oscillations throughout the ship, they were usually retracted for planetary operations.

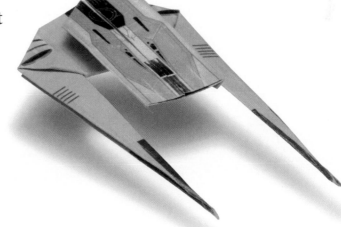

HOW TO FOLD: U-WING

1 Start colored side down. Valley fold and unfold. Repeat on the other two corners.

2 Valley fold and unfold.

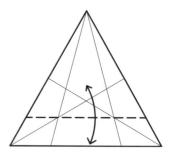

3 Valley fold and unfold.

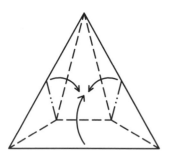

4 Make two simultaneous rabbit ear folds.

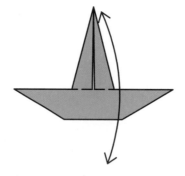

5 Valley fold and unfold.

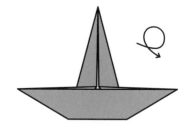

6 Turn over.

7 Valley fold and unfold.

8 Valley fold and unfold.

9 Valley fold and unfold.

10 Sink fold.

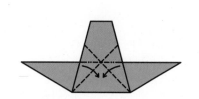

11 Collapse on the existing creases.

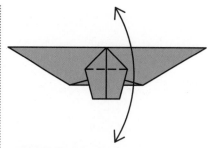

12 Mark fold.

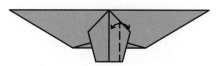

13 Valley fold and unfold. Repeat on the left.

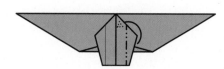

14 Valley fold and unfold. Repeat on the left.

15 Turn over.

16 Valley fold and unfold.

17 Valley fold.

18 Valley fold, incorporating a squash fold at A.

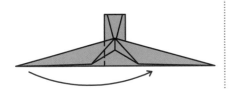

19 Valley fold.

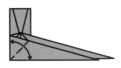

20 Valley fold and unfold.

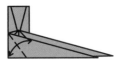

21 Valley fold and unfold.

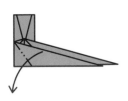

22 Squash fold.

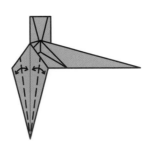

23 Valley fold and unfold.

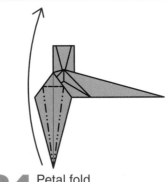

24 Petal fold.

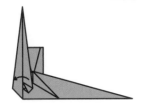

25 Valley fold.

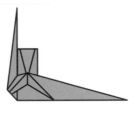

26 Repeat steps 19 through 25 on the right side.

27 Turn over.

28 Finished U-wing in landing configuration. Continue for flight configuration.

29 Reverse fold the wings.

30 Swivel the wing so edge AB is parallel to edge AC. Repeat on the right.

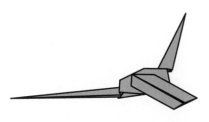

31 Finished U-wing in flight configuration. Unfold to step 28 for landing configuration.

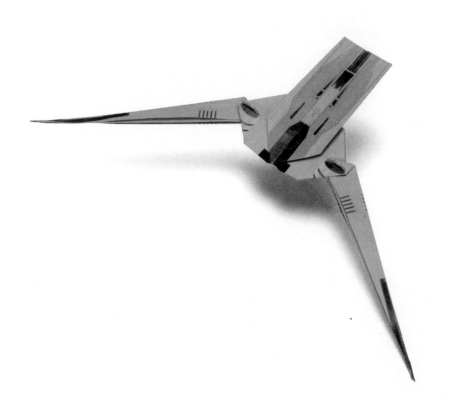

ZORII BLISS' HELMET

Zorii Bliss was the ambidextrous leader of the Kijimi Spice Runners, a group of pirates that protected Kessel spice-trade routes left vulnerable by the collapse of the Empire and the death of Jabba the Hutt. Zorii joined the Spice Runners as a teenager and soon met Poe Dameron, another teenage Spice Runner recruit, whose piloting skills complemented her underworld survival instincts. The two made a powerful team, and the Spice Runners suffered when Poe left the group. Zorii became leader of the Spice Runners in the midst of the galactic conflict between the Resistance and the First Order, and she was forced to choose between staying neutral or assisting in the battle against the First Order.

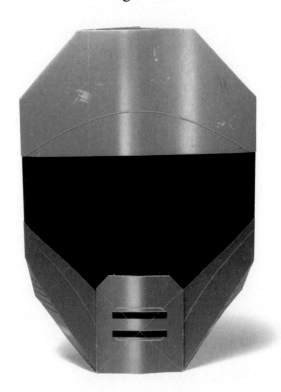

HOW TO FOLD: ZORII BLISS' HELMET

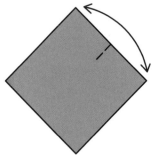

1 Start colored side down. Mark fold.

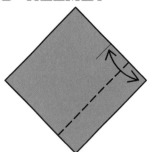

2 Valley fold and unfold.

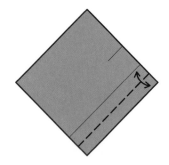

3 Valley fold and unfold.

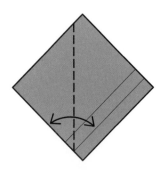

4 Valley fold and unfold.

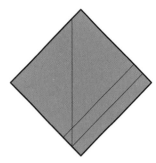

5 Repeat steps 1 through 4 on the left side.

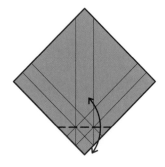

6 Valley fold and unfold.

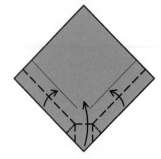

7 Collapse on the existing creases. Start with the sides, then fold the corner on top.

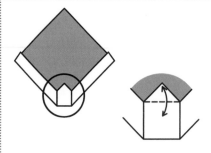

8 Mark fold.

9 Mark fold.

10 Valley fold so the crease formed in step 8 lands on the crease formed in step 9.

11 Fold the triangle to the back.

12 Valley fold to the edge and unfold.

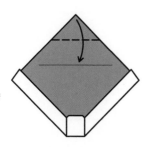

13 Valley fold.

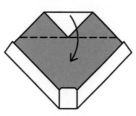

14 Valley fold on the crease formed in step 12.

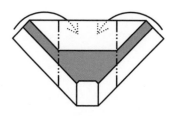

15 Mountain fold.

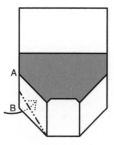

16 Mountain fold. The crease starts halfway between A and B. Repeat on the right.

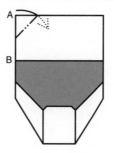

17 Mountain fold. The crease starts halfway between A and B. Repeat on the right.

18 Finished Zorii Bliss' Helmet.

TIE STRIKER

The TIE striker was a variant of the Sienar Systems' famed TIE series of starfighters. Its flattened wings gave it superior maneuverability in an atmospheric dogfight. The solar panels could pivot at the hull, giving the pilot the ability to trade off agility for speed as the situation required. The craft was armed with proton bombs and four sets of laser cannons, making it well suited for supporting ground assaults and protecting high-value fixed assets.

HOW TO FOLD: TIE STRIKER

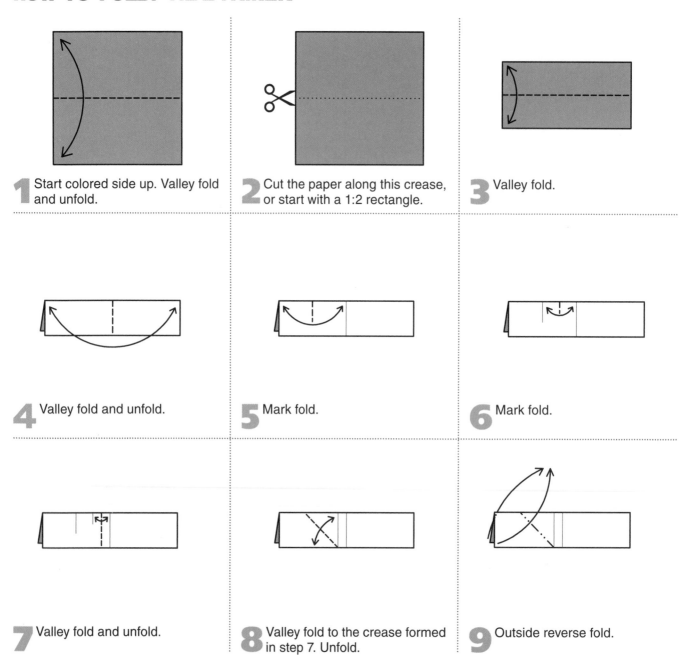

1 Start colored side up. Valley fold and unfold.

2 Cut the paper along this crease, or start with a 1:2 rectangle.

3 Valley fold.

4 Valley fold and unfold.

5 Mark fold.

6 Mark fold.

7 Valley fold and unfold.

8 Valley fold to the crease formed in step 7. Unfold.

9 Outside reverse fold.

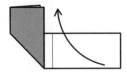

10 Repeat steps 5 through 9 on the right side.

11 Valley fold and unfold.

12 Sink both sides of the creases formed in step 11.

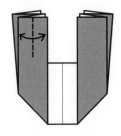

13 Mark fold.

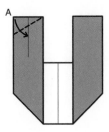

A

14 Valley fold corner A to the crease formed in step 13.

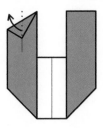

15 Unfold.

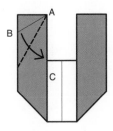

A

B

C

16 Valley fold so crease AB lands on edge AC.

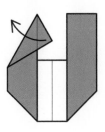

17 Unfold to step 16.

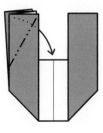

18 Reverse fold only the top flap.

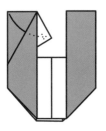

19 Valley fold the lower flap into the pocket formed in step 18.

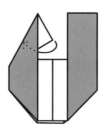

20 Mountain fold into the lower pocket.

21 Repeat steps 13 through 20 on the right side.

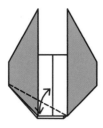

22 Valley fold and unfold. Repeat behind.

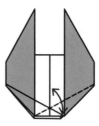

23 Valley fold and unfold. Repeat behind.

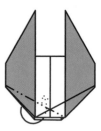

24 Mountain fold on the crease formed in step 22. Repeat behind.

25 Mountain fold on the crease formed in step 23. Repeat behind.

26 Valley fold.

27 Valley fold and unfold.

28 Valley fold using the same angle as step 27.

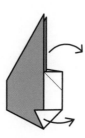

29 Unfold to step 26.

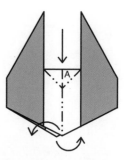

30 Push in at A while spreading and squashing the white area.

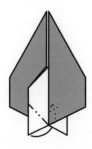

31 Reverse fold on the crease formed in step 28.

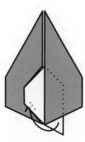

32 Reverse fold on the crease formed in step 28 and into the pocket formed in step 31.

33 Pull the wings outward about half the distance of step 30. Allow the cockpit to puff out.

34 Finished TIE Striker.

INDEX

PROJECTS BY LEVEL OF DIFFICULTY

Some of the models in this book are easier to fold than others, and they are grouped into four levels of difficulty: Youngling (easy), Padawan (medium), Jedi Knight (difficult), and Jedi Master (very tricky!). Unless you're already an origami guru, you might want to start with the Youngling or Padawan models first.

YOUNGLING (EASY)

PORG .. 25
T-16 SKYHOPPER .. 29
SUPER STAR DESTROYER, THE *EXECUTOR* 35
ZORII BLISS' HELMET .. 223

PADAWAN (MEDIUM)

LIGHTSABERS ... 19
BB-8 ... 41
DARTH VADER .. 47
DEATH TROOPER HELMET 53
OBI-WAN KENOBI'S JEDI STARFIGHTER 59
FIRST ORDER STAR DESTROYER, THE *FINALIZER* 81
D-O .. 165
FINN .. 173
KYLO REN'S MASK .. 181

JEDI KNIGHT (DIFFICULT)

SEBULBA'S PODRACER .. 65
SUPREME LEADER SNOKE 73
FIRST ORDER STORMTROOPERS 89
SITH TROOPER HELMET .. 95
K-2SO ... 97
A-WING ... 157
U-WING ... 217
TIE STRIKER ... 227

JEDI MASTER (VERY TRICKY!)

KYLO REN'S TIE WHISPER 105
Y-WING ... 113
LANDO CALRISSIAN'S *MILLENNIUM FALCON* 121
GENERAL GRIEVOUS' STARFIGHTER, THE *SOULLESS ONE* .. 129
LANDO CALRISSIAN .. 135
SITH INFILTRATOR .. 145
KYLO REN'S TIE SILENCER 151
REY'S JAKKU SPEEDER .. 187
POE DAMERON'S T-70 X-WING 195
PRAETORIAN GUARD ... 205

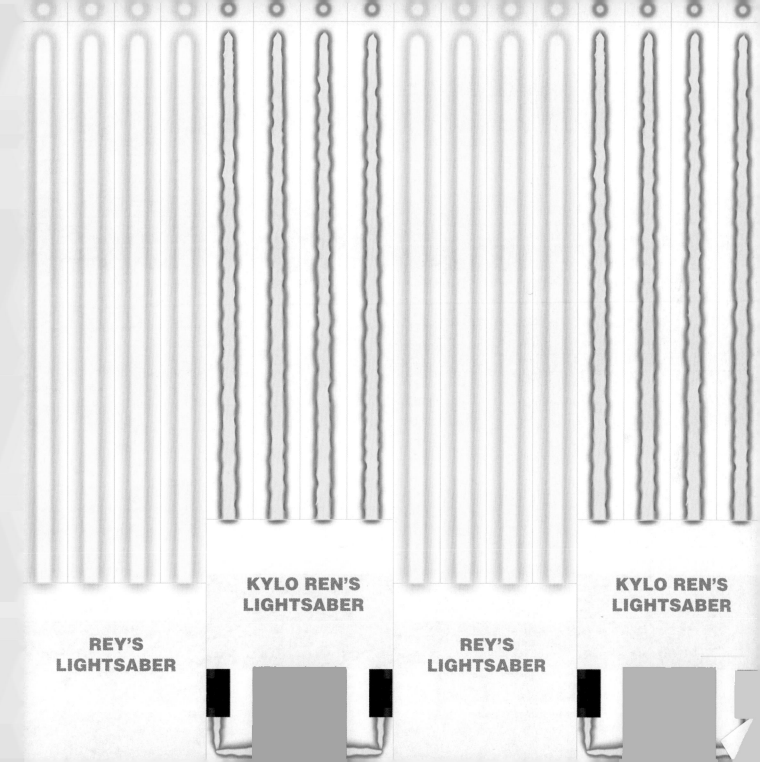

REY'S
LIGHTSABER

KYLO REN'S
LIGHTSABER

REY'S
LIGHTSABER

KYLO REN'S
LIGHTSABER

**KYLO REN'S
LIGHTSABER**
START THIS SIDE UP
PAGE 19

**REY'S
LIGHTSABER**
START THIS SIDE UP
PAGE 19

**KYLO REN'S
LIGHTSABER**
START THIS SIDE UP
PAGE 19

**REY'S
LIGHTSABER**
START THIS SIDE UP
PAGE 19

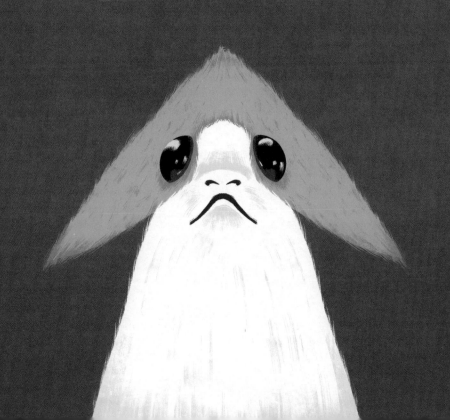

PORG
START THIS SIDE UP
PAGE 25

start step 4
with this side up

start step 4
with this side up

PORG
START THIS SIDE DOWN
PAGE 25

PORG
START THIS SIDE UP
PAGE 26

start step 4
with this side up

start step 4
with this side up

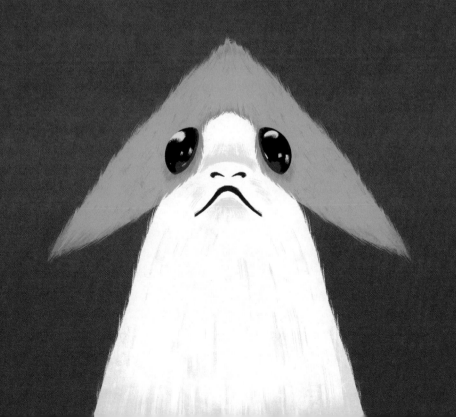

PORG

START THIS SIDE DOWN

PAGE 25

use this line

for steps 4 and 6

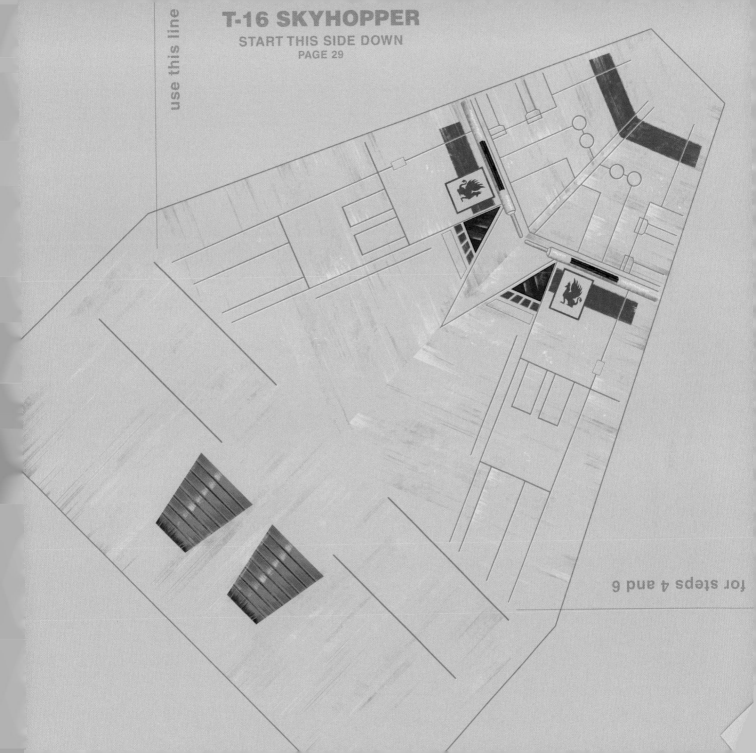

▲ start with this corner at the top

T-16 SKYHOPPER
START THIS SIDE UP
PAGE 29

use this line

for steps 4 and 6

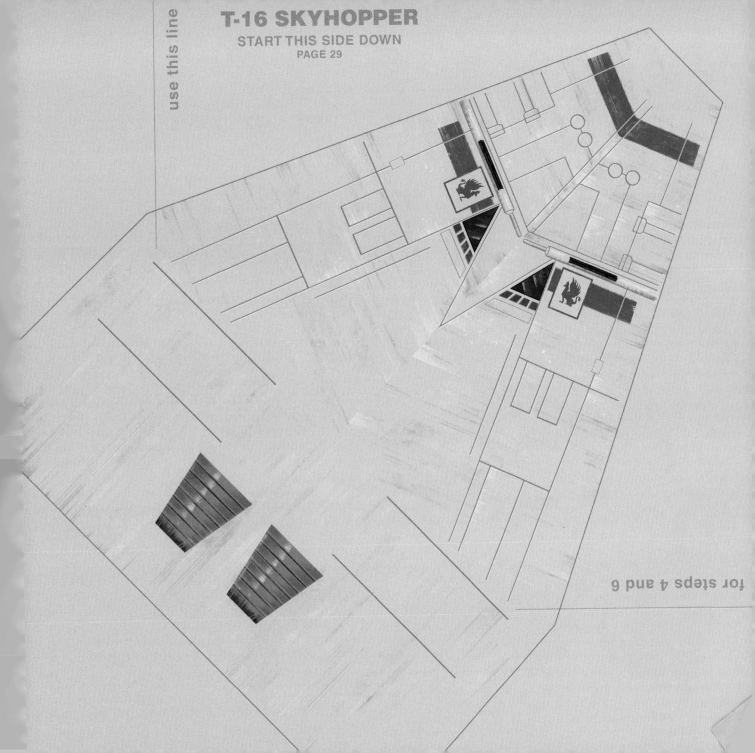

▼ start with this corner at the top

T-16 SKYHOPPER
START THIS SIDE UP
PAGE 29

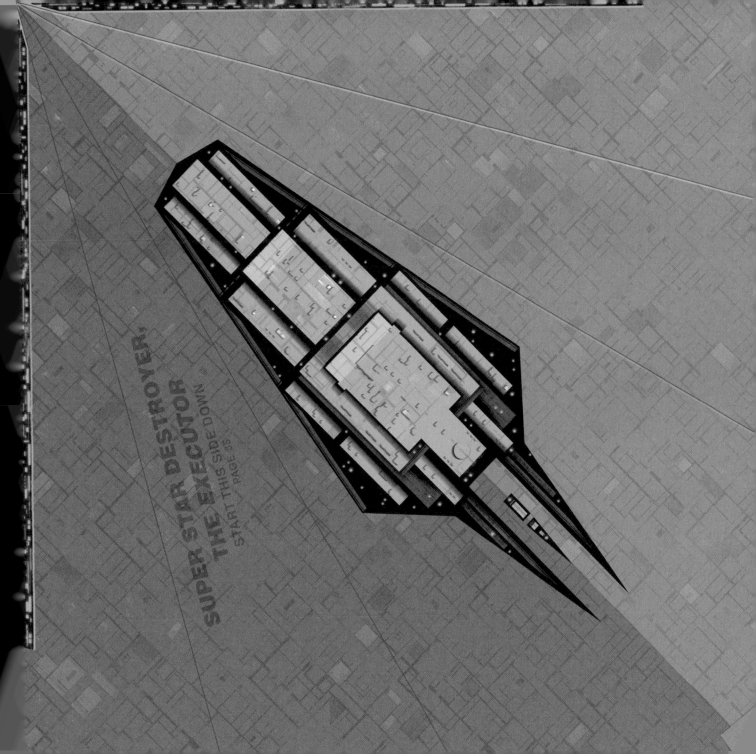

SUPER STAR DESTROYER,
THE EXECUTOR
START THIS SIDE DOWN
PAGE 35

start with this corner at the top ▶

SUPER STAR DESTROYER,
THE *EXECUTOR*

START THIS SIDE UP

PAGE 35

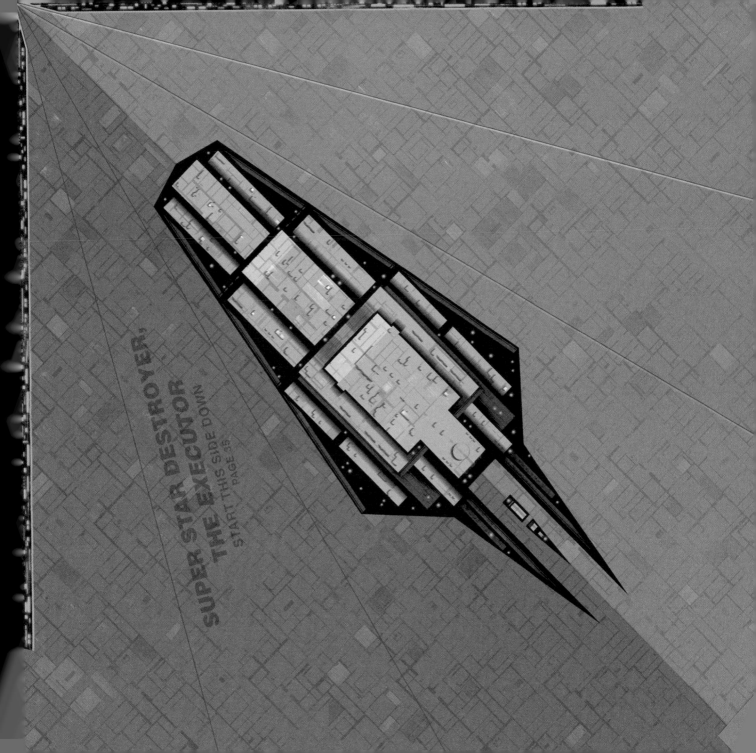

SUPER STAR DESTROYER,
THE EXECUTOR
START THIS SIDE DOWN
PAGE 35

start with this corner at the top ▼

SUPER STAR DESTROYER,
THE *EXECUTOR*
START THIS SIDE UP
PAGE 35

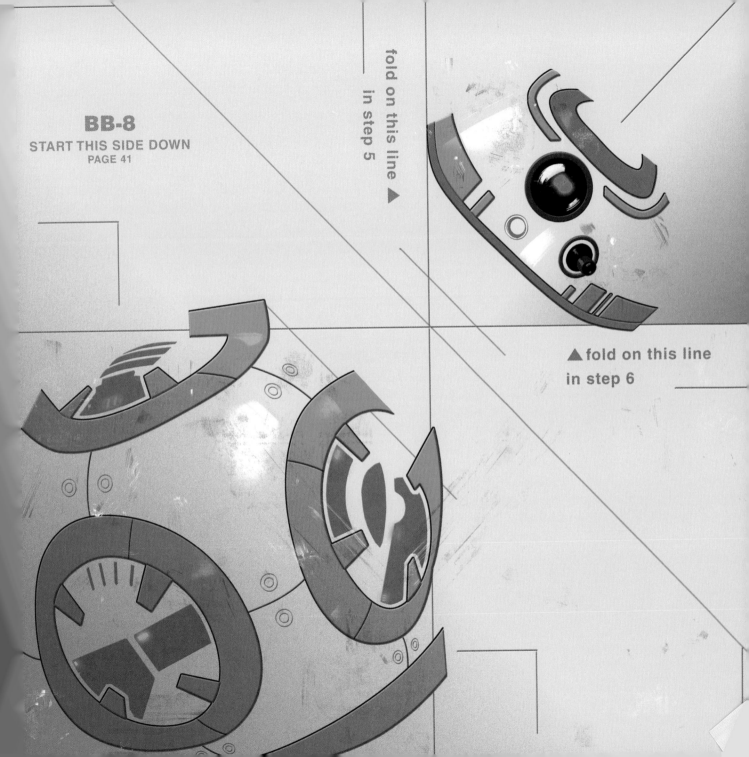

BB-8
START THIS SIDE DOWN
PAGE 41

fold on this line ▶
in step 5

▲ fold on this line
in step 6

start with this edge at the top

BB-8

START THIS SIDE UP
PAGE 41

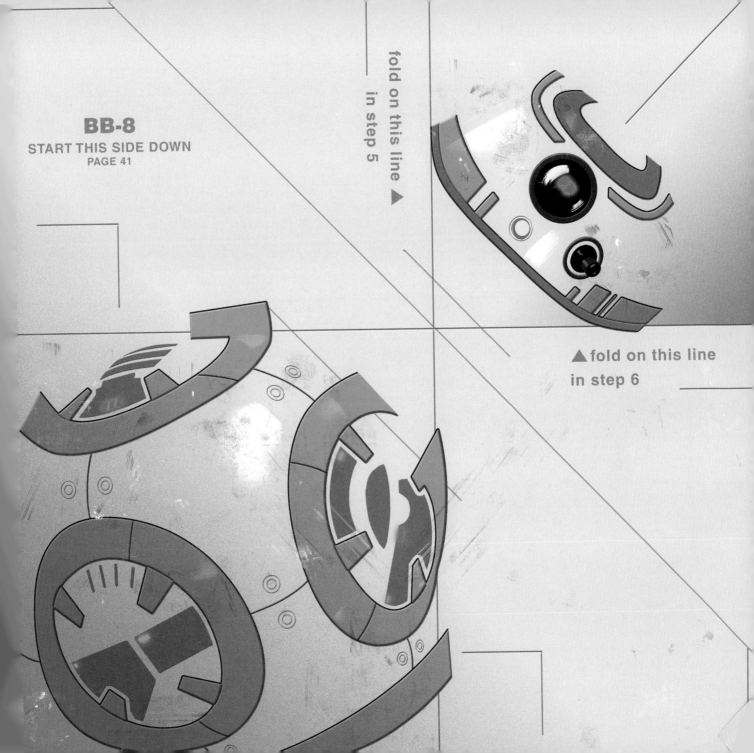

BB-8
START THIS SIDE DOWN
PAGE 41

fold on this line ▶
in step 5

▲fold on this line
in step 6

start with this edge at the top

BB-8

START THIS SIDE UP
PAGE 41

DARTH VADER

START THIS SIDE DOWN
PAGE 47

start with this edge at the top

DARTH VADER

START THIS SIDE UP
PAGE 47

DARTH VADER

START THIS SIDE DOWN
PAGE 47

DARTH VADER
START THIS SIDE UP
PAGE 47

Start with this edge at the top

DEATH TROOPER HELMET

START THIS SIDE UP
PAGE 53

DEATH TROOPER
HELMET
START THIS SIDE DOWN
PAGE 53

DEATH TROOPER HELMET

START THIS SIDE UP
PAGE 53

start with this corner at the top ▼

OBI-WAN KENOBI'S JEDI STARFIGHTER
START THIS SIDE DOWN

start with this point at the bottom

OBI-WAN KENOBI'S JEDI STARFIGHTER

START THIS SIDE DOWN

PAGE 59

▲ start with this corner at the bottom

OBI-WAN KENOBI'S JEDI STARFIGHTER

START THIS SIDE DOWN

start with this point at the bottom

OBI-WAN KENOBI'S JEDI STARFIGHTER

START THIS SIDE DOWN
PAGE 59

▲ start with this corner at the bottom

start with this
corner at the top

SEBULBA'S PODRACER
START THIS SIDE UP
PAGE 65

SEBULBA'S PODRACER
START THIS SIDE DOWN
PAGE 65

start with this edge at the bottom

start with this
corner at the top

SEBULBA'S PODRACER
START THIS SIDE UP
PAGE 65

SEBULBA'S PODRACER
START THIS SIDE DOWN
PAGE 65

start with this edge at the bottom

SUPREME LEADER SNOKE
START THIS SIDE UP
PAGE 73

start with this
corner at the
bottom

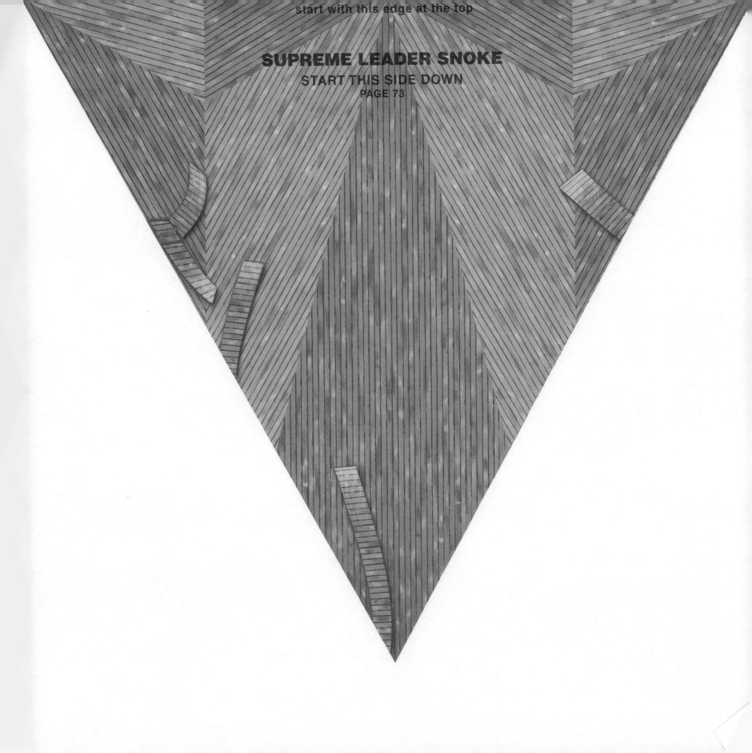

SUPREME LEADER SNOKE
START THIS SIDE UP
PAGE 73

start with this
corner at the
bottom

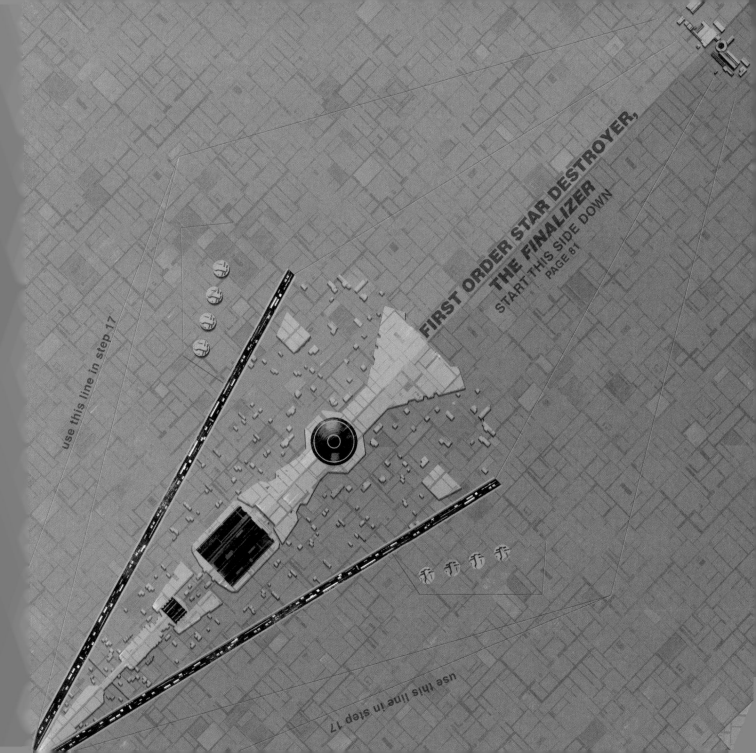

FIRST ORDER STAR DESTROYER,
THE FINALIZER
START THIS SIDE DOWN
PAGE 81

use this line in step 17

use this line in step 17

▼ start with this
corner at the top

FIRST ORDER STAR DESTROYER,
THE *FINALIZER*

START THIS SIDE UP
PAGE 81

FIRST ORDER STAR DESTROYER,
THE FINALIZER
START THIS SIDE DOWN
PAGE 81

use this line in step 17

use this line in step 17

start with this
corner at the top

FIRST ORDER STAR DESTROYER,
THE *FINALIZER*
START THIS SIDE UP
PAGE 81

start with this
edge at the top

FIRST ORDER
STORMTROOPER HELMET

START THIS SIDE DOWN
PAGE 89

**FIRST ORDER
STORMTROOPER HELMET**

START THIS SIDE UP
PAGE 89

start with this
edge at the top

FIRST ORDER
STORMTROOPER HELMET

START THIS SIDE DOWN
PAGE 89

start with this edge at the top

FIRST ORDER
STORMTROOPER HELMET
START THIS SIDE UP
PAGE 89

start with this
edge at the top

FIRST ORDER
STORMTROOPER
HELMET FN-2187 (FINN)

START THIS SIDE DOWN
PAGE 89

FIRST ORDER
STORMTROOPER
HELMET FN-2187 (FINN)

START THIS SIDE UP
PAGE 89

start with this
edge at the top

FIRST ORDER
STORMTROOPER
HELMET FN-2187 (FINN)

START THIS SIDE DOWN
PAGE 89

**FIRST ORDER
STORMTROOPER
HELMET FN-2187 (FINN)**

START THIS SIDE UP
PAGE 89

start with this
edge at the top

CAPTAIN PHASMA'S HELMET
START THIS SIDE DOWN
PAGE 89

CAPTAIN PHASMA'S HELMET
START THIS SIDE UP
PAGE 89

start with this
edge at the top

CAPTAIN PHASMA'S HELMET
START THIS SIDE DOWN
PAGE 89

start with this edge at the top

CAPTAIN PHASMA'S HELMET
START THIS SIDE UP
PAGE 89

start with this
edge at the top

SITH TROOPER HELMET
START THIS SIDE DOWN
PAGE 95

start with this edge at the top

SITH TROOPER HELMET
START THIS SIDE UP
PAGE 95

start with this
edge at the top

SITH TROOPER HELMET
START THIS SIDE DOWN
PAGE 95

SITH TROOPER HELMET
START THIS SIDE UP
PAGE 95

start with this edge at the top

K-2SO
START THIS SIDE DOWN
PAGE 97

start with this edge at the top

K-2SO
START THIS SIDE UP
PAGE 97

start with this edge at the top

K-2SO
START THIS SIDE DOWN
PAGE 97

K-2SO
START THIS SIDE UP
PAGE 97

cut out the square

TIE WHISPER
COCKPIT
START THIS
SIDE DOWN
PAGE 105

cut out the square

cut out the square

▼ ▼

start with this edge at the top

TIE WHISPER COCKPIT
START THIS SIDE UP
PAGE 105

cut out the square

▲ ▲

cut out the square

TIE WHISPER
COCKPIT
START THIS
SIDE DOWN
PAGE 105

cut out the square

▼ cut out the square ▼

start with this edge at the top

TIE WHISPER COCKPIT
START THIS SIDE UP
PAGE 105

▲ cut out the square ▲

TIE WHISPER WING

START THIS SIDE DOWN PAGE 105

start with this corner to the right ▶

TIE WHISPER WING
START THIS SIDE UP
PAGE 105

TIE WHISPER WING

START THIS SIDE DOWN PAGE 105

start with this corner to the right.

TIE WHISPER WING
START THIS SIDE UP
PAGE 105

START THIS SIDE DOWN PAGE 105

TIE WHISPER WING

start with this corner to the right.

TIE WHISPER WING
START THIS SIDE UP
PAGE 105

TIE WHISPER WING

START THIS SIDE DOWN PAGE 105

start with this corner to the right.

TIE WHISPER WING

START THIS SIDE UP

PAGE 105

Y-WING FUSELAGE

PAGE 113

Y-WING COCKPIT

PAGE 113

hide this flap
in step 20

this side up for step 15

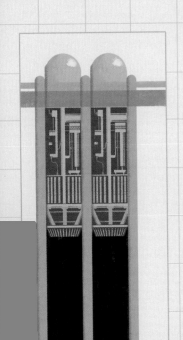

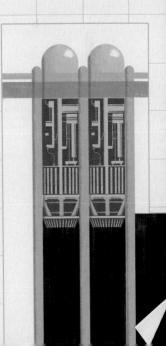

fold this flap in step 19

start with this edge at the top

Y-WING FUSELAGE
START THIS SIDE UP
PAGE 113
fold this section second

▼ cut in half along this line ▼

start with this edge at the top

Y-WING COCKPIT
START THIS SIDE UP
PAGE 113

fold this section first

Y-WING FUSELAGE

PAGE 113

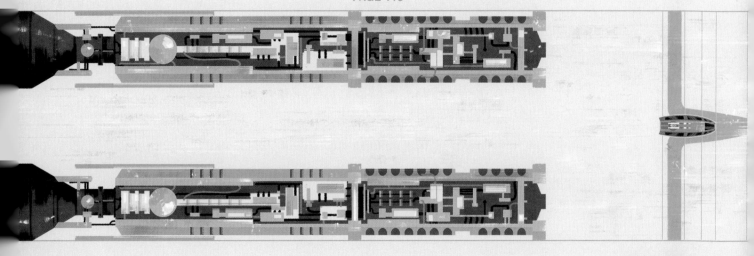

Y-WING COCKPIT

PAGE 113

hide this flap
in step 20

this side up for step 15

fold this flap in step 19

start with this edge at the top

Y-WING FUSELAGE
START THIS SIDE UP
PAGE 113

fold this section second

▼ cut in half along this line ▼

start with this edge at the top

Y-WING COCKPIT
START THIS SIDE UP
PAGE 113

fold this section first

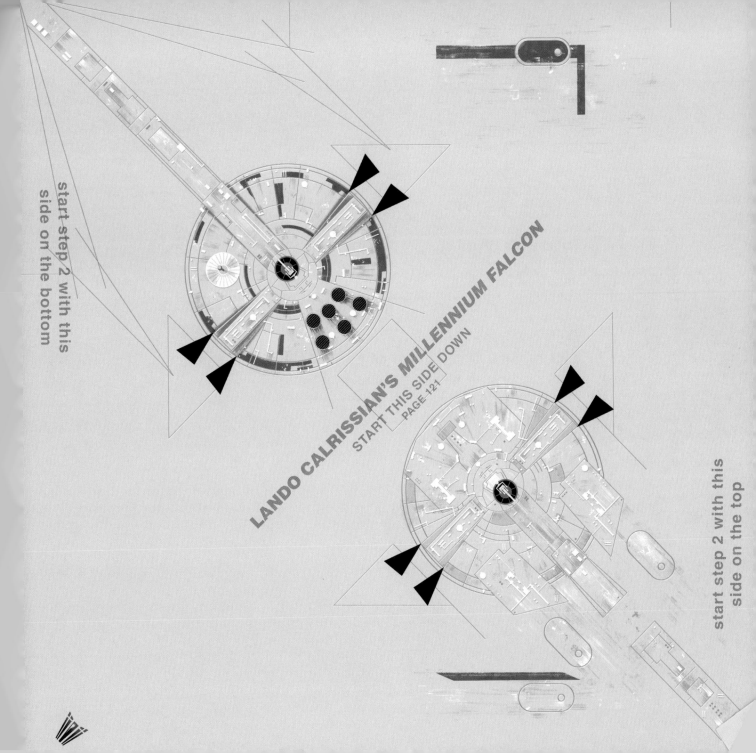

start step 2 with this
side on the bottom

LANDO CALRISSIAN'S MILLENNIUM FALCON

START THIS SIDE DOWN
PAGE 121

start step 2 with this
side on the top

LANDO CALRISSIAN'S *MILLENNIUM FALCON*
START THIS SIDE UP
PAGE 121

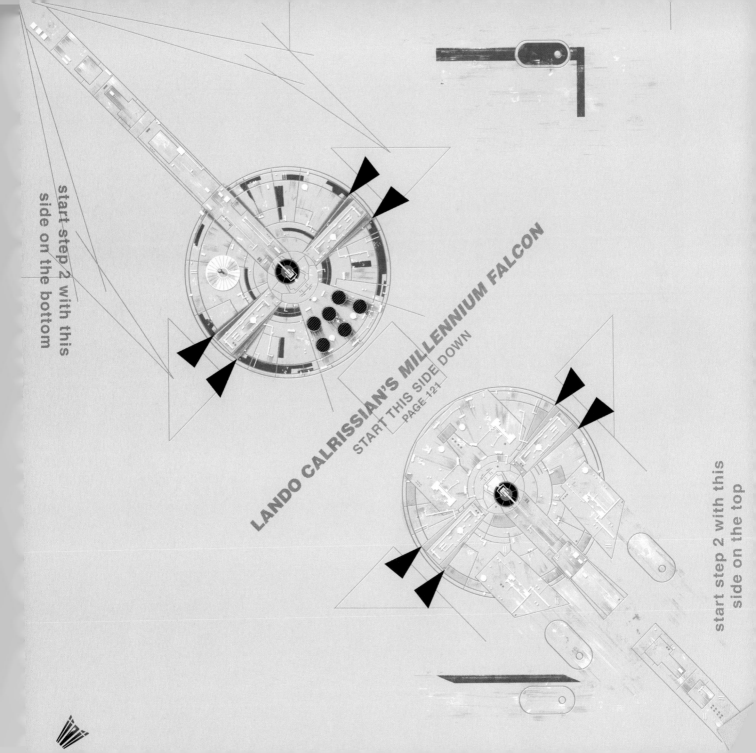

LANDO CALRISSIAN'S MILLENNIUM FALCON

START THIS SIDE DOWN
PAGE 121

start-step 2 with this
side on the bottom

start step 2 with this
side on the top

LANDO CALRISSIAN'S *MILLENNIUM FALCON*
START THIS SIDE UP
PAGE 121

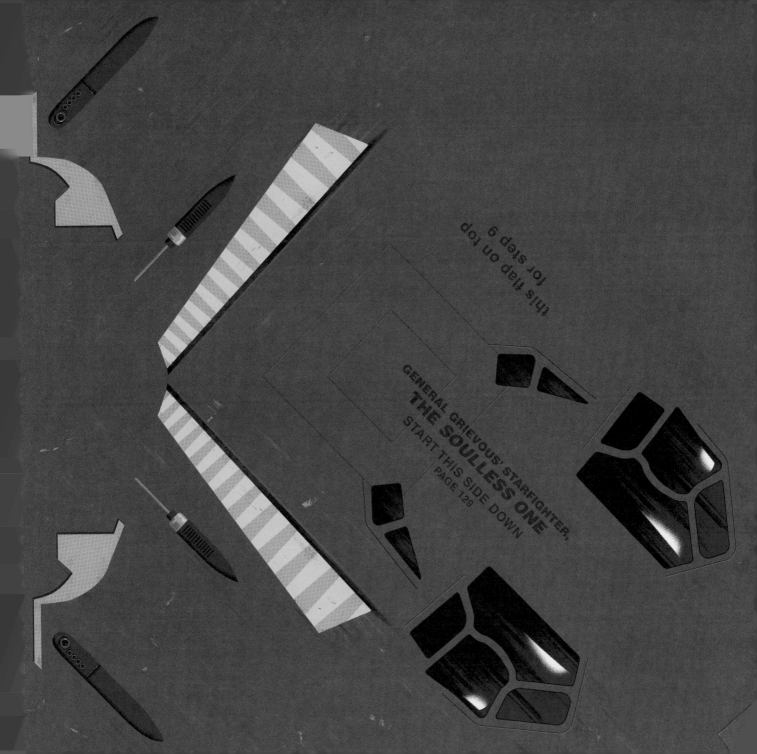

GENERAL GRIEVOUS' STARFIGHTER,
THE SOULLESS ONE
START THIS SIDE DOWN
PAGE 129

this flap on top
for step 9

start with this corner at the top

GENERAL GRIEVOUS' STARFIGHTER,
THE *SOULLESS ONE*
START THIS SIDE UP
PAGE 129

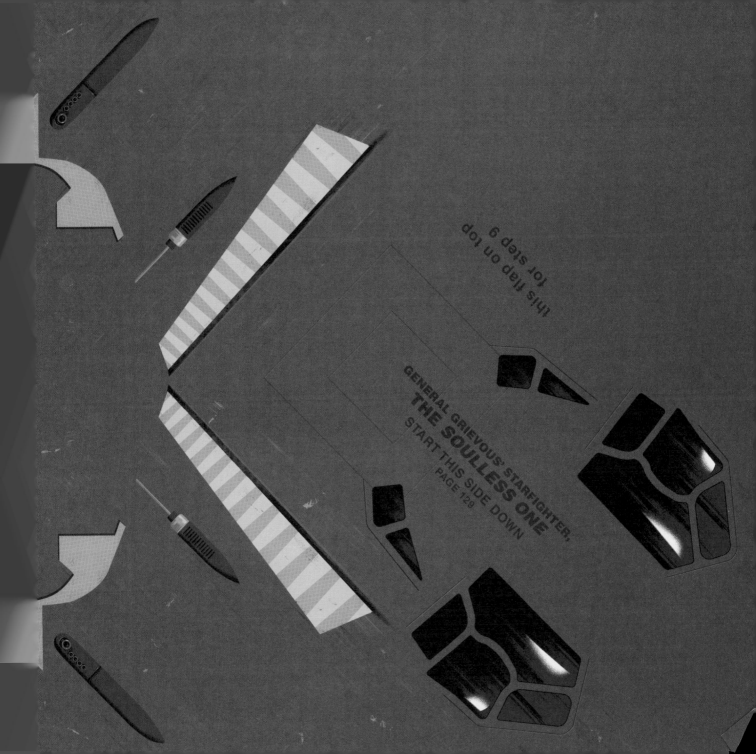

GENERAL GRIEVOUS' STARFIGHTER,
THE SOULLESS ONE
START THIS SIDE DOWN
PAGE 129

this flap on top
for step 9

start with this corner at the top

GENERAL GRIEVOUS' STARFIGHTER,
THE *SOULLESS ONE*
START THIS SIDE UP
PAGE 129

LANDO CALRISSIAN
START THIS SIDE DOWN
PAGE 135

for step 27

this side up

sink
flap
step

this
in
19

LANDO CALRISSIAN
START THIS SIDE UP
PAGE 135

LANDO CALRISSIAN
START THIS SIDE DOWN
PAGE 135

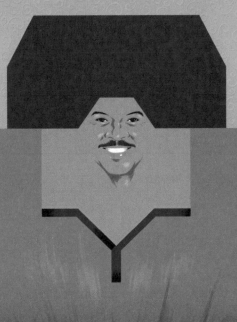

for step 27

this side up

sink
flap
step

this
in
19

LANDO CALRISSIAN

START THIS SIDE UP
PAGE 135

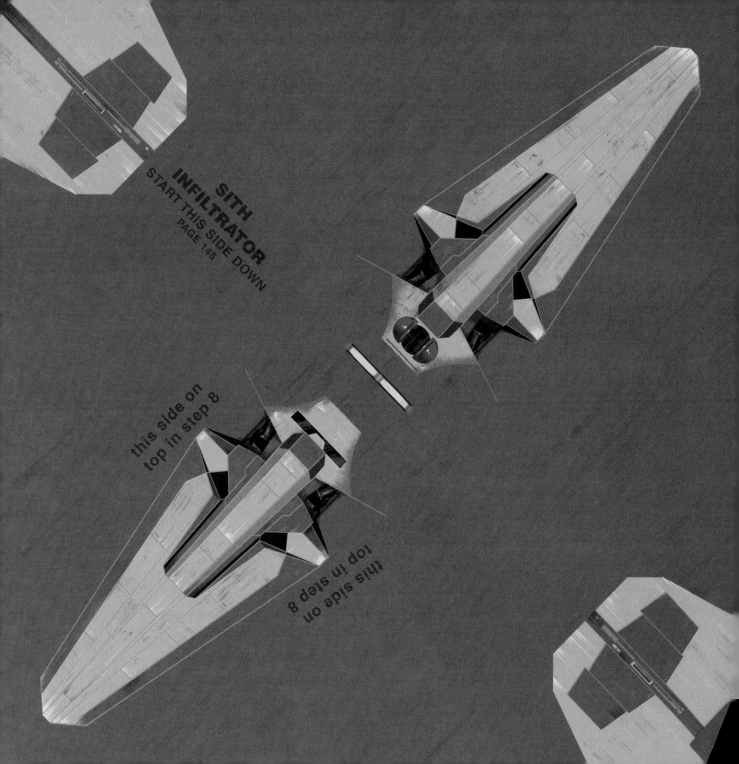

SITH
INFILTRATOR
START THIS SIDE DOWN
PAGE 145

this side on
top in step 8

this side on
top in step 8

SITH INFILTRATOR
START THIS SIDE UP
PAGE 145

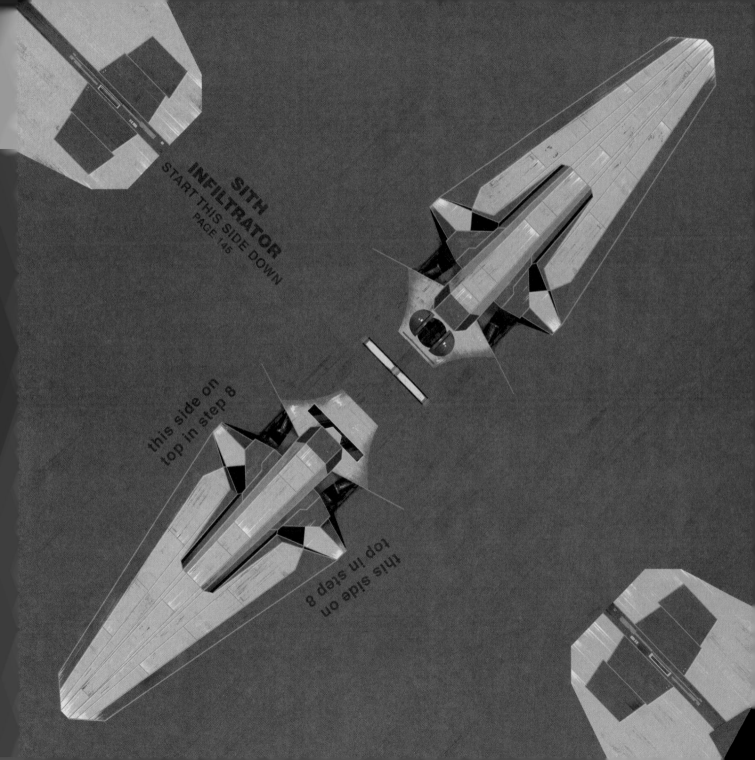

SITH
INFILTRATOR
START THIS SIDE DOWN
PAGE 145

this side on
top in step 8

this side on
top in step 8

SITH INFILTRATOR

START THIS SIDE UP
PAGE 145

this side up in step 14

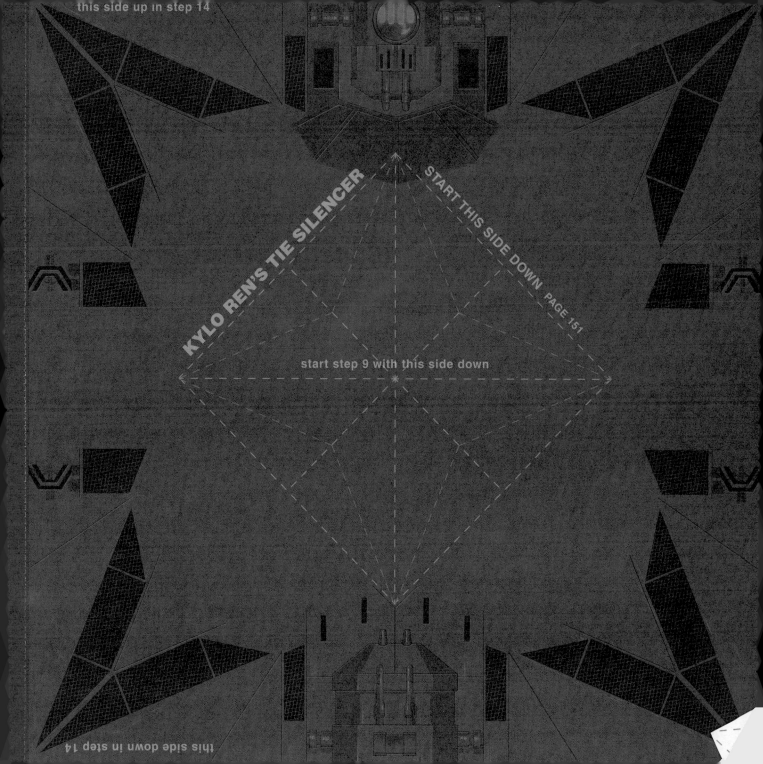

KYLO REN'S TIE SILENCER

START THIS SIDE DOWN PAGE 151

start step 9 with this side down

this side down in step 14

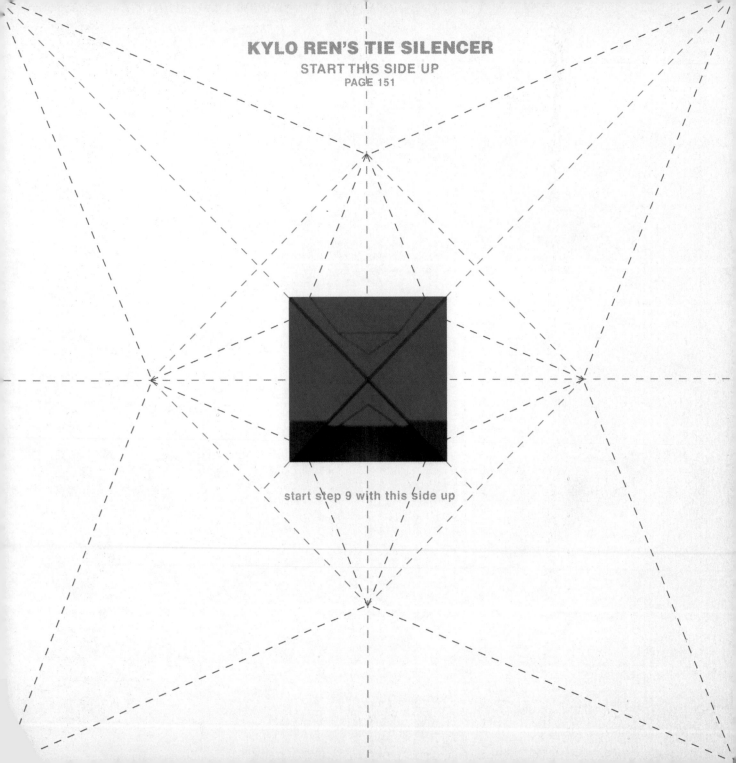

KYLO REN'S TIE SILENCER
START THIS SIDE UP
PAGE 151

start step 9 with this side up

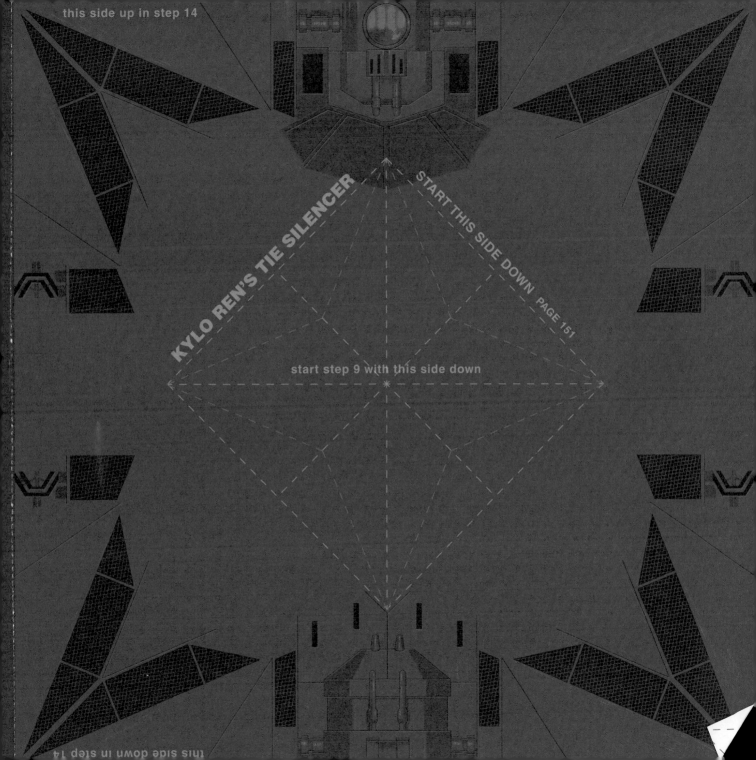

this side up in step 14

KYLO REN'S TIE SILENCER

START THIS SIDE DOWN PAGE 151

start step 9 with this side down

this side down in step 14

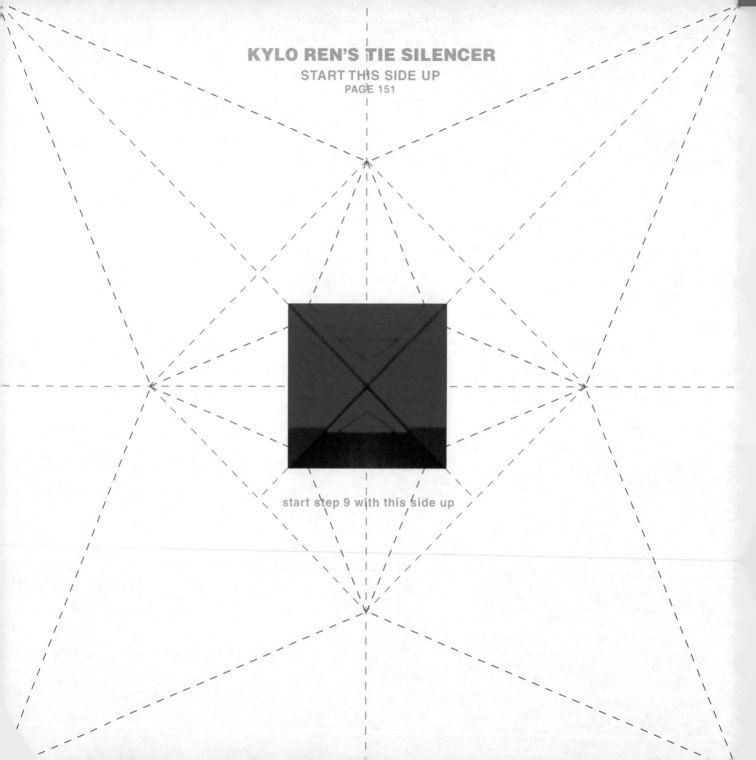

KYLO REN'S TIE SILENCER
START THIS SIDE UP
PAGE 151

start step 9 with this side up

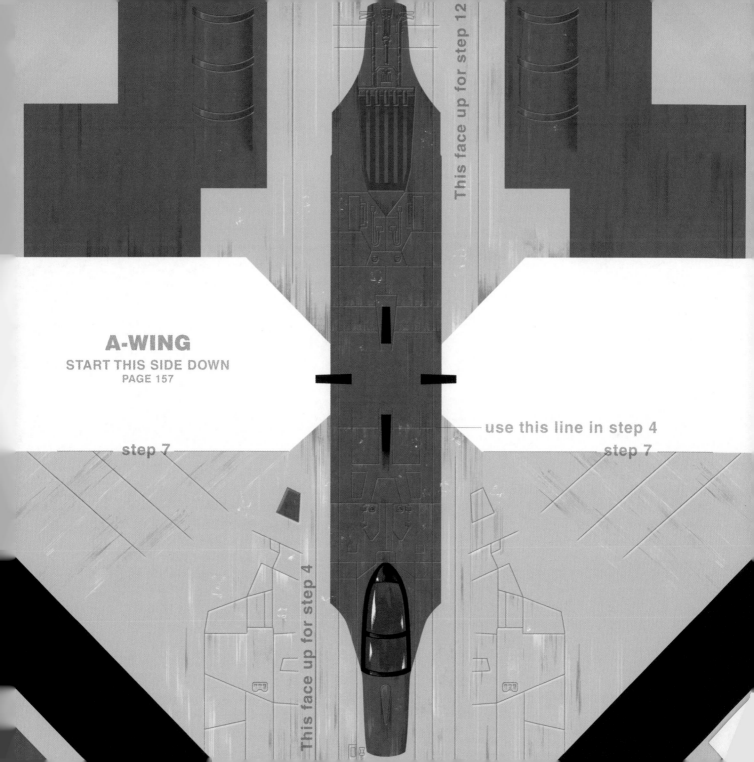

A-WING
START THIS SIDE DOWN
PAGE 157

This face up for step 12

This face up for step 4

use this line in step 4

step 7

step 7

A-WING
START THIS SIDE UP
PAGE 157

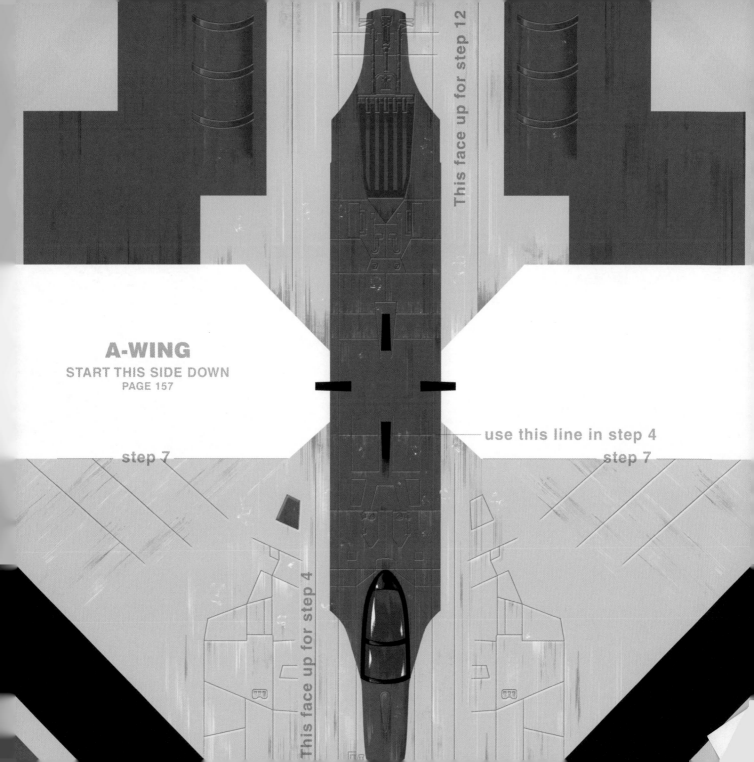

A-WING
START THIS SIDE UP
PAGE 157

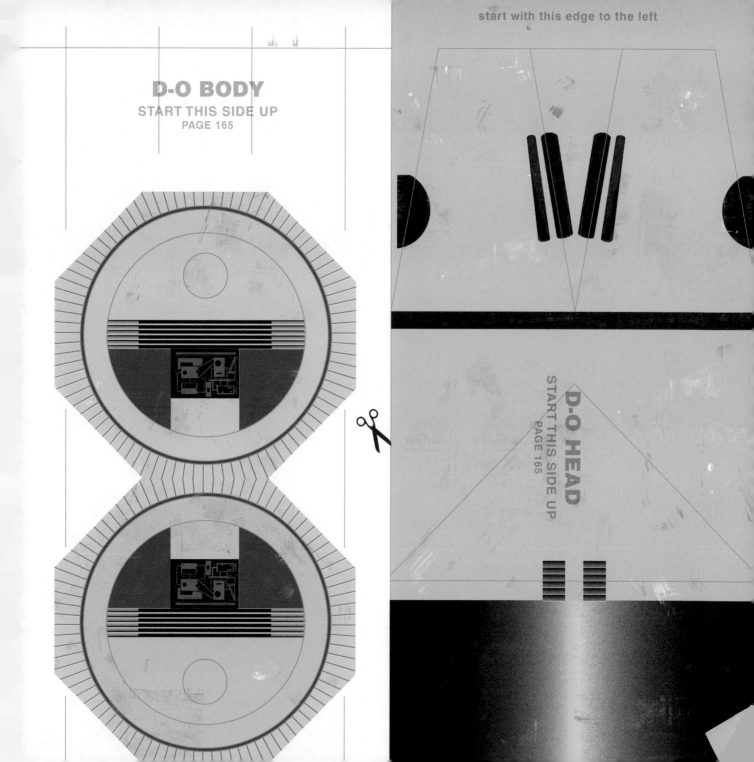

D-O BODY
START THIS SIDE UP
PAGE 165

D-O HEAD
START THIS SIDE UP
PAGE 165

▼

cut in half along this line

▼

D-O HEAD

START THIS SIDE DOWN
PAGE 165

D-O BODY

START THIS SIDE DOWN
PAGE 165

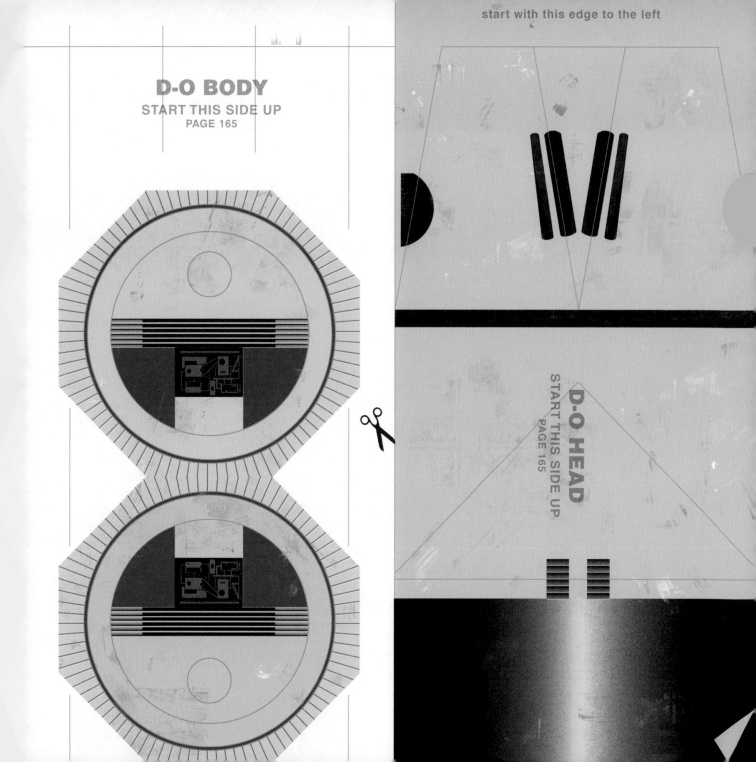

D-O BODY
START THIS SIDE UP
PAGE 165

D-O HEAD
START THIS SIDE UP
PAGE 165

start with this edge at the top

▲

cut in half along this line

▲

D-O HEAD

START THIS SIDE DOWN
PAGE 165

D-O BODY

START THIS SIDE DOWN
PAGE 165

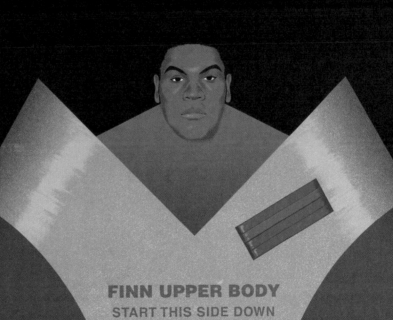

FINN UPPER BODY

START THIS SIDE DOWN

PAGE 173

start with this
corner at the
bottom

FINN UPPER BODY
START THIS SIDE UP
PAGE 173

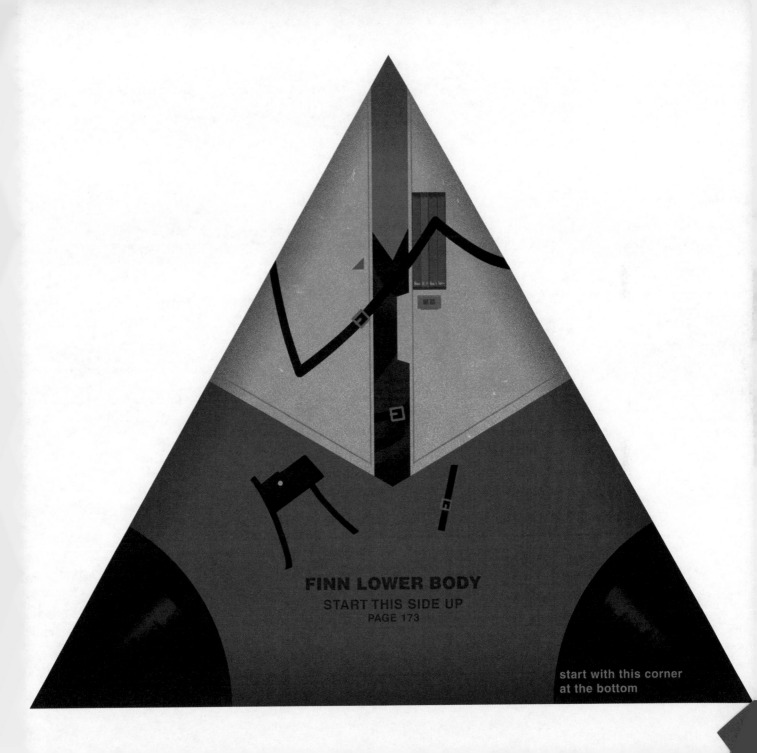

FINN LOWER BODY
START THIS SIDE UP
PAGE 173

start with this corner
at the bottom

FINN LOWER BODY
START THIS SIDE DOWN
PAGE 173

start with this
corner at the
bottom

▲

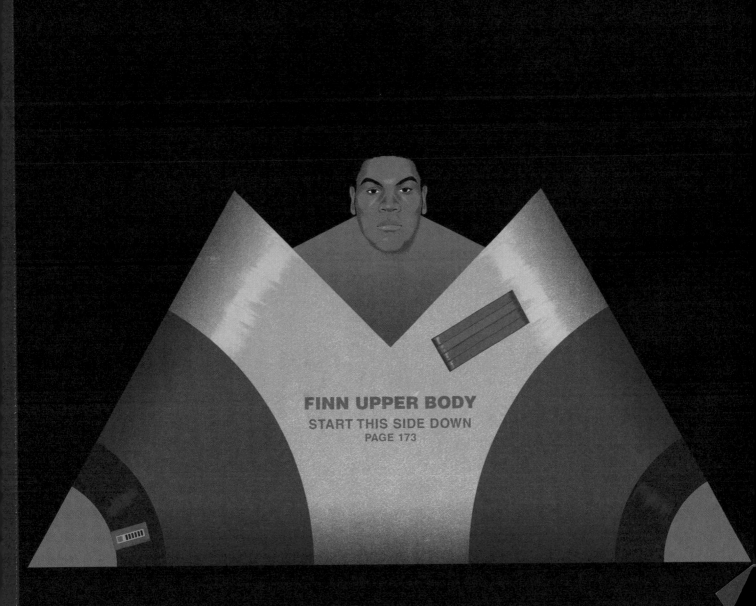

FINN UPPER BODY

START THIS SIDE DOWN
PAGE 173

▲

start with this
corner at the
bottom

FINN UPPER BODY

START THIS SIDE UP
PAGE 173

FINN LOWER BODY
START THIS SIDE UP
PAGE 173

start with this corner
at the bottom

FINN LOWER BODY

START THIS SIDE DOWN
PAGE 173

start with this
corner at the
bottom

▲

start with this
corner at the top

KYLO REN'S MASK
START THIS SIDE DOWN
PAGE 181

KYLO REN'S MASK
START THIS SIDE UP
PAGE 181

start with this
corner at the top

▲

KYLO REN'S MASK

START THIS SIDE DOWN

PAGE 181

KYLO REN'S MASK

START THIS SIDE UP
PAGE 181

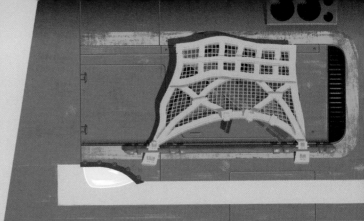

REY'S JAKKU SPEEDER

START THIS SIDE DOWN
PAGE 187

start with this edge
at the bottom

start with this edge at the bottom

REY'S JAKKU SPEEDER
START THIS SIDE UP
PAGE 187

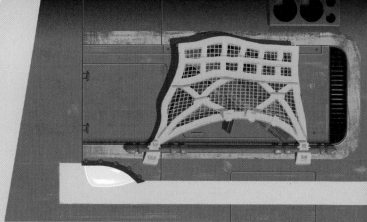

REY'S JAKKU SPEEDER
START THIS SIDE DOWN
PAGE 187

start with this edge
at the bottom

REY'S JAKKU SPEEDER
START THIS SIDE UP
PAGE 187

start with this edge at the bottom

this
up in

side
step

52

sink this flap
in step
43

sink this flap
in step
43

POE DAMERON'S T-70 X-WING

START THIS SIDE DOWN
PAGE 195

45

this
up in

side
step

POE DAMERON'S T-70 X-WING

START THIS SIDE UP

PAGE 195

this
up in

side
step

52

sink this flap
in step
43

POE DAMERON'S T-70 X-WING

START THIS SIDE DOWN
PAGE 195

sink this flap
in step
43

45

side
step

this
up in

**PRAETORIAN GUARD
LOWER BODY**
START THIS SIDE DOWN
PAGE 205

this side
up in
step 19

**PRAETORIAN GUARD
LOWER BODY**
START THIS SIDE UP
PAGE 205

PRAETORIAN GUARD
UPPER BODY
START THIS SIDE DOWN PAGE 205

this side up in step 31

this side up in step 29

start with this edge at the top

PRAETORIAN GUARD
UPPER BODY
START THIS SIDE UP
PAGE 205

**PRAETORIAN GUARD
LOWER BODY**
START THIS SIDE DOWN
PAGE 205

this side
up in
step 19

PRAETORIAN GUARD
LOWER BODY
START THIS SIDE UP
PAGE 205

PRAETORIAN GUARD
UPPER BODY
START THIS SIDE DOWN PAGE 205

this side
up in
step 31

this side
up in
step 29

start with this edge at the top

PRAETORIAN GUARD
UPPER BODY
START THIS SIDE UP
PAGE 205

U-WING

START THIS SIDE DOWN
PAGE 217

start with this corner at the top

U-WING
START THIS SIDE UP
PAGE 217

U-WING
START THIS SIDE DOWN
PAGE 217

start with this corner at the top

U-WING
START THIS SIDE UP
PAGE 217

start with this
corner at the top ▶

ZORII BLISS' HELMET
START THIS SIDE DOWN
PAGE 223

ZORII BLISS' HELMET
START THIS SIDE UP
PAGE 223

ZORII BLISS' HELMET
START THIS SIDE DOWN
PAGE 223

ZORII BLISS' HELMET

START THIS SIDE UP

PAGE 223